AIRBRUS

Tools • Techniques • Materials

BY PETER WEST

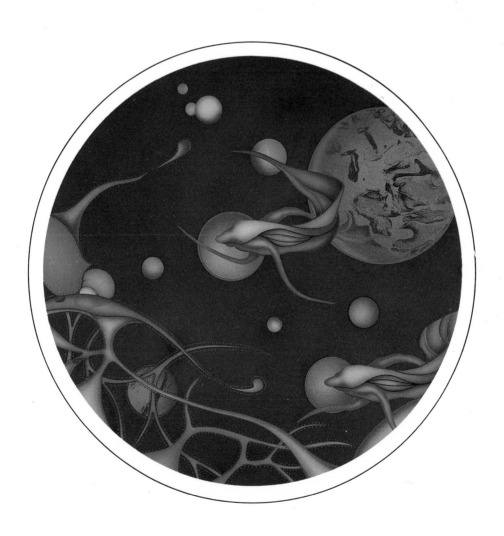

Walter Foster Publishing, Inc.
430 West Sixth Street, Tustin, CA 92680-9990

CONTENTS

(Note: Information on Stenciling appears on pages 4, 14, 17, 26, 29, 30, 32, 34.)

Dedicated to Betsy and Helen

INTRODUCTION

The tool referred to as airbrush was not invented until the late nineteenth century; however, the concept of spraying pigment dates back much further. It is estimated that over thirty-five thousand years ago prehistoric cave dwellers created images by blowing pigment through hollow pieces of bone onto their cave walls. In several examples of these prehistoric paintings, silhouettes of human hands appear, indicating the early artists' use of their own hands as a form of stencil.

As the airbrush emerged into the twentieth century, its initial use was in the retouching of photography. During this time, sepia-colored photographs rendered with the airbrush became extremely popular. As a result of this popularity, studios equipped for several airbrush technicians were established to retouch and color photographs in a production-line manner.

From the 1920's to the present day, the field of COMMERCIAL GRAPHICS has enthusiastically utilized airbrush in many applications. For example, MEDICAL ILLUSTRATORS find airbrush unsurpassed for rendering organic forms and creating naturalistic skin tones. Airbrushed, cut-a-way renderings of machinery produced by the TECHNICAL ILLUSTRATOR have become a standard means of illustrating the internal workings of machines. In the area of PHOTO RETOUCHING, airbrush is used extensively in magazine advertisements for tasks such as the enhancement of automobile chrome or spraying out a cluttered background surrounding a product.

In contrast to commercial graphics, the realm of FINE ART has viewed the airbrush somewhat differently. Considered by many artists to be exclusively a designer's tool, the airbrush did not gain wide acceptance in the fine arts until the 1960's and 1970's. A major factor contributing to its acceptance as a fine artist's tool was the development of the POP ART movement. As the movement grew during the 1960's, more and more so-called commercial techniques such as airbrush and photo silkscreen were used to create fine art. As a result, the notion of separating techniques into categories of commercial or fine art became outdated, and acceptance of the airbrush spread quickly.

Other factors which helped popularize airbrush, especially with the general public, are custom automotive and T-shirt painting. Currently, the airbrush is used in almost every facet of the visual arts and has gained a reputation as a valuable and most versatile tool.

In essence, an airbrush is a tool which atomizes a liquid medium which is then propelled onto a painting surface with the aid of an AIR SOURCE. This makes the airbrush unique in comparison to other painting and drawing tools in that it delivers color to the surface without actually touching the surface. Applying color in this manner gives the mark produced by an airbrush a soft, fuzzy appearance in comparison to the relatively hard edge mark or stroke produced by other painting and drawing tools.

When the spray leaves the airbrush, it develops into a circular form which is referred to as the SPRAY or SPRAY PATTERN. The spray pattern is actually a suspended mass of tiny color particles which can be regulated in volume from a fine line to a broad area of smooth, uniform color.

When the airbrush is regulated to heavier spray settings, you will discover that the color becomes increasingly diffused. You will also notice increasing amounts of color falling outside the main body of the spray pattern. The material that falls outside the main body of the spray pattern is referred to as OVERSPRAY. When very heavy spray settings are used, excessive overspray will develop. This results in a light dusting of your work and surrounding surfaces. Most of the overspray produced from heavy spraying is actually dry before reaching your surface and may be removed with a draftman's dust brush.

Considering the soft and diffused nature of the spray pattern, a means of controlling the color must be implemented in order to create a form with a defined, hard edge. This brings us to an essential element of airbrush technique, the STENCIL. Stencils block out predetermined areas of the painting surface and expose only selected areas for spraying. Once the exposed areas have been airbrushed, the stencil is removed, thus creating the contour of the form and also giving it a sharp, hard edge.

Another factor unique to spraying color opposed to more traditional applications is its transparent qualities. The spray pattern consists of hundreds of color particles or dots of color which fall adjacent to each other on the painting surface. The space appearing between the dots is of course the painting surface itself. The dots of sprayed color in turn visually blend with the surface color beneath, thus creating a transparent effect. It should be noted that by applying color in the form of a spray permits even opaque pigments to take on a transparent character. Applying the color in this manner also provides the ability to layer several different colors without diminishing their overall vibrancy. Most of the color in airbrush painting is actually mixed directly on the painting surface by spraying layers of many colors, one upon another to achieve the desired color. This approach proficiently produces images with multiple yet subtle color changes as well.

The information appearing in this introduction and following pages will furnish an overall understanding of airbrush techniques and equipment. This book can also serve as a valuable guide for choosing the appropriate media, stenciling material and painting surfaces. In conjunction with the guidelines for choosing airbrush supplies provided here, question your local art supplier as well. Experiment with a variety of painting surfaces, stenciling materials and painting medias. A major contributing factor to successful airbrushing is simply using the right combination of materials.

Enjoy the instruction and inspiration that this book will provide in achieving your airbrushing goals.

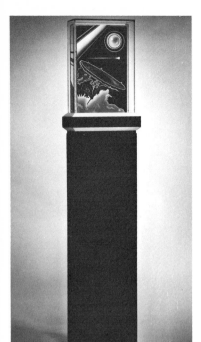

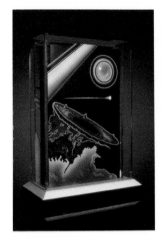

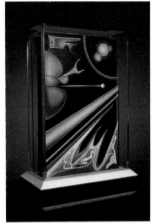

PETER WEST
AIRBRUSHED PLEXIGLASS CONSTRUCTION

Collection Pennsylvania State Univ.
Acrylics on plexiglass construction
with formica base. 5'8" x 15" x 8"

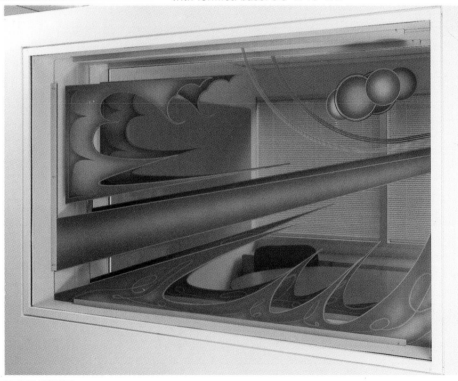

PETER WEST
AIRBRUSHED WALL INSTALLATION

Collection Westinghouse Credit Corporation, Pittsburgh, PA
Two transparent plexiglass panels mounted in-wall/
glass encased. 3½' x 5' x 30".

THE AIRBRUSH

There are three types of airbrushes most commonly used in airbrush painting today:

Single-Action, Internal-Mix

Double-Action, Internal-Mix

Single-Action, External-Mix

Each airbrush has different capabilities which should be carefully studied before deciding to use a specific type. The fineness of SPRAY PATTERN desired, VISCOSITY and TYPE of PIGMENT to be used are a few important factors to consider when choosing an airbrush.

A brief study of the color coded chart and supporting information will provide an overview of the basic construction of each airbrush. Followed by this is a more detailed description of the spray characteristics and operational procedures of the individual airbrush types. Cleaning and maintenance which proceeds each description is covered in a generalized manner. Although several manufacturers may produce the same basic types of airbrushes, none will have exactly the same design or construction. The manufacturer's INSTRUCTION MANUAL included with every airbrush will provide the specific information necessary for cleaning and maintaining your particular make and model. Read this material carefully before hooking up your airbrush.

Note: The airbrush descriptions are generic in nature. (Your make and model may differ to some extent.)

BASIC AIRBRUSH ANATOMY

All airbrushes are constructed with two major features: the ACTION and the MIX.

ACTION: The ACTION refers to the configuration of parts that triggers your airbrush. The ACTION comes in two versions: single or double. These terms describe the method by which each action is triggered.

SINGLE-ACTION airbrushes are triggered with one finger movement. Pushing down on the trigger releases a preset amount of spray. The volume of color sprayed is regulated by setting a SPRAY ADJUSTMENT PART prior to depressing the trigger.

DOUBLE-ACTION airbrushes are triggered with two finger movements. PRESSING DOWN on the trigger releases air, and PULLING BACK releases the color. As the trigger is pulled further back the volume of spray increases. Pushing the trigger forward to its original position reverses the setting and reduces the spray pattern.

MIX: The MIX refers to the method and location in which the air and liquid are brought together and atomized into a spray. This process can take place either inside or outside the airbrush HEAD. It is this difference which defines each airbrush as either INTERNAL- or EXTERNAL-MIX.

INTERNAL-MIX airbrushes bring the air and liquid together inside the airbrush HEAD. The internal-mix atomizes the liquid thoroughly which results in a smooth, uniform spray.

EXTERNAL-MIX airbrushes bring the air and liquid together and atomize them outside the airbrush head. Delivering the liquid in this manner produces a coarse or stippled spray.

THE ACTION		THE MIX	
SINGLE-ACTION	DOUBLE-ACTION	INTERNAL-MIX	EXTERNAL-MIX
●	●	○	●

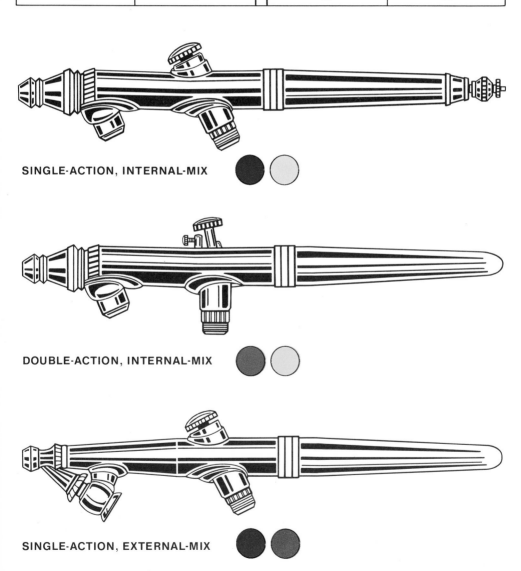

SINGLE-ACTION, INTERNAL-MIX

DOUBLE-ACTION, INTERNAL-MIX

SINGLE-ACTION, EXTERNAL-MIX

SUPPLYING THE PIGMENT: All airbrushes require a reservoir to hold and feed the liquid medium to the airbrush. Liquid is fed by two different methods: SUCTION or GRAVITY-FEED.

SUCTION: Models using this method draw liquid into the airbrush with a container positioned either underneath or to either side of the airbrush body. Both BOTTOM-FEED and SIDE-FEED models utilize the SUCTION method.

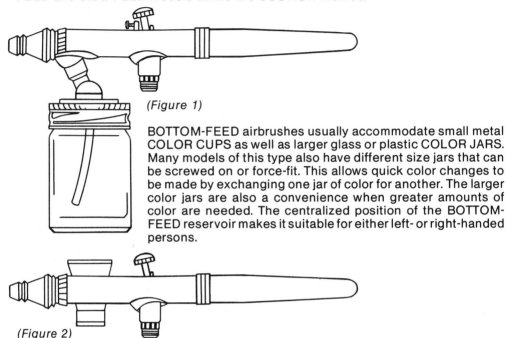

(Figure 1)

BOTTOM-FEED airbrushes usually accommodate small metal COLOR CUPS as well as larger glass or plastic COLOR JARS. Many models of this type also have different size jars that can be screwed on or force-fit. This allows quick color changes to be made by exchanging one jar of color for another. The larger color jars are also a convenience when greater amounts of color are needed. The centralized position of the BOTTOM-FEED reservoir makes it suitable for either left- or right-handed persons.

(Figure 2)

SIDE-FEED models usually accommodate only the smaller color cup. Most manufacturers of side-feed airbrushes have both left- and right-handed models.

GRAVITY: Models of this type rely on gravity to direct the liquid into the airbrush.

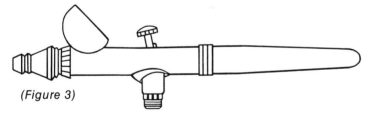

(Figure 3)

GRAVITY-FEED models position the reservoir on top of and attached to the airbrush body. This type is also suitable for either left- or right-handed persons.

When producing finely detailed renderings, the airbrush must be positioned very close to the painting surface. In these instances larger paint jars or cups may interfere with the positioning necessary for extremely close work. Artists who consistently work in this manner may prefer a GRAVITY-FEED model which permits the airbrush to be placed as close to the painting surface as desired without obstruction from the container.

When changing colors with a gravity-feed airbrush, the color cup must be cleaned between each change in color. Also, the permanent color cup attached to most models of this kind is fairly small and may prove to be impractical for the average user.

In general, the BOTTOM-FEED AIRBRUSH which accommodates both the COLOR CUP and JARS is the most convenient and versatile.

DETAILED AIRBRUSH DESCRIPTIONS

Note: Carefully review each description as well as the one pertaining to your particular model. Much of this information overlaps from one airbrush type to another. A review of all three will provide a comprehensive understanding of the airbrush's overall characteristics.

SINGLE-ACTION, INTERNAL-MIX

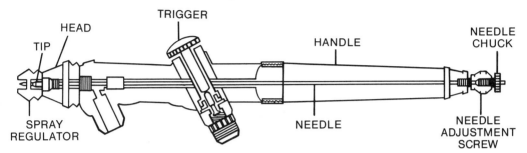

OPERATION: Triggering the SINGLE-ACTION airbrush is accomplished with a single finger movement. Simply pushing down on the trigger will release a PRESET amount of spray.

Single-action, internal-mix airbrushes are regulated by a NEEDLE that runs centrally through the body and into the HEAD ASSEMBLY (see cut-a-way view). Attached to the needle are a NEEDLE ADJUSTMENT SCREW and CHUCK (located at the back end of the handle). Turning the needle adjustment screw clockwise REDUCES your spray setting by moving the needle forward (into and through) the TIP. The tip is a small, hollow part attached to the front portion of the airbrush HEAD through which color passes as it leaves the airbrush. As the needle is moved forward it reduces the opening of the tip, thus allowing less color to pass through. Spray settings can be reduced to an extent to which the needle completely closes off the tip, not allowing any color to pass. Turning the needle adjustment screw counterclockwise INCREASES the spray setting by backing the needle out of the tip, thus enlarging the opening and allowing more color to be sprayed. When changing spray settings on a SINGLE-ACTION airbrush, it is necessary to stop spraying while the change is made.

SPRAY CHARACTERISTICS: The term INTERNAL-MIX indicates that air and liquid come together and become atomized inside the airbrush HEAD. This creates a thoroughly atomized spray.

The HEAD is one of three parts which make up the airbrush's HEAD ASSEMBLY. The head assembly consists of the SPRAY REGULATOR, TIP and HEAD. Many SINGLE-ACTION, INTERNAL-MIX airbrushes have INTERCHANGEABLE HEAD ASSEMBLIES available in three sizes: fine, medium and heavy. The size of each HEAD ASSEMBLY determines the overall size range of spray patterns which the airbrush can produce. Use of a HEAVY ASSEMBLY permits pigments of a heavier viscosity to be sprayed.

Spray patterns produced by INTERNAL-MIX airbrushes are generally smooth, uniform and softer in appearance in comparison to the coarse, stippled spray produced by EXTERNAL-MIX models. This difference is a result of the ability of the internal-mix model to more thoroughly atomize the color. Most SINGLE-ACTION, INTERNAL-MIX airbrushes produce spray patterns ranging in approximate size from the width of a fine pencil line up to two inches.

APPLICATIONS: (Single-Action, Internal-Mix) airbrushes are popular in the hobby and craft areas. Easy to operate and maintain, this airbrush makes a good choice for painting models, T-shirts, ceramics and decorative stenciling. Although not extensively used in graphic illustration or photo retouching, this model is commonly used for basic applications in these areas. Note: The relative ease of operation/maintenance makes it an excellent choice for the BEGINNER as well.

DOUBLE-ACTION, INTERNAL-MIX

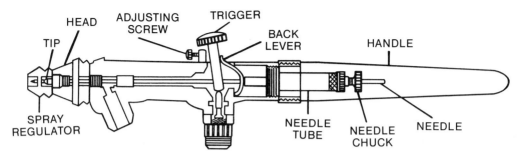

OPERATION: Triggering of the DOUBLE-ACTION airbrush is accomplished with TWO finger movements: PUSHING DOWN on the trigger releases AIR, and PULLING BACK releases color. The volume of color sprayed directly corresponds to how far the trigger is pulled back. For example, when airbrushing a fine line the trigger is only slightly drawn back. In comparison, heavy spray settings require pulling the trigger further back which increases the volume of spray. Reversing from a heavy setting to a fine setting simply requires pushing the trigger forward to its original position. The DOUBLE-ACTION provides the ability to regulate spray patterns gradually and consistently by changing the position of the trigger. UNLIKE single-action models it is not necessary to stop airbrushing while making a change in the spray setting. This gives the DOUBLE-ACTION airbrush inherently more versatility than the single-action types.

DOUBLE-ACTION airbrushes are also regulated by a needle that runs through the body and into a HEAD ASSEMBLY, just as it does with its SINGLE-ACTION counterpart. (See cut-a-way view.) The needle is moved in and out of the TIP, which in turn increases or decreases spray release, exactly as described for the single-action, internal-mix airbrush. DOUBLE-ACTION models differ by the method in which the needle is moved backward and forward. As illustrated in the cut-a-way view, the needle is threaded through openings in the stem of the airbrush TRIGGER and also an S-shaped part called a BACK LEVER. When the trigger is positioned backward and forward, the needle moves in UNISON with the trigger's movements. Should the trigger be pulled back and simply released, it will instantly spring forward to its original forward position. Proper alignment of back lever, trigger and needle is crucial for achieving the tension necessary to spring the trigger forward.

Another feature of some double-action airbrushes is the ADJUSTING SCREW (see cut-a-way). The adjusting screw can be screwed inward, pushing the trigger backward, thus PRESETTING the trigger to a specific spray setting.

The double-action, internal-mix airbrush is available with BOTTOM-, SIDE-, and GRAVITY-FEED reservoirs. (See *Figures 1, 2, 3; page 8*.) The side- and gravity-feed models are most appropriate for precision ILLUSTRATION, PHOTO RETOUCHING or any type of finely-rendered work. As RECOMMENDED earlier, the BOTTOM-FEED models which accommodate containers of different sizes are generally the most convenient and versatile.

SPRAY CHARACTERISTICS: The spray characteristics of INTERNAL-MIX airbrushes, whether SINGLE- or DOUBLE-ACTION, are virtually identical. Atomization of color takes place in exactly the same manner and location; it is only their triggering actions which set them apart. Another common characteristic of some DOUBLE-ACTION, INTERNAL-MIX and SINGLE-ACTION, INTERNAL-MIX airbrushes is an INTERCHANGEABLE head assembly. This expands their versatility. Most double-action, internal-mix models produce spray patterns ranging in size from approximately the width of a fine pencil line to two inches.

APPLICATIONS: The double-action, internal-mix model is involved in almost every airbrush application. All facets of graphic design, illustration and photo retouching utilize the double-action, internal-mix airbrush. The added control of the DOUBLE-ACTION and the smooth, uniform spray of its INTERNAL-MIX make this model ideal for graphic and fine artists alike. This model is RECOMMENDED for all areas of commercial graphics and fine art.

SINGLE-ACTION, EXTERNAL-MIX

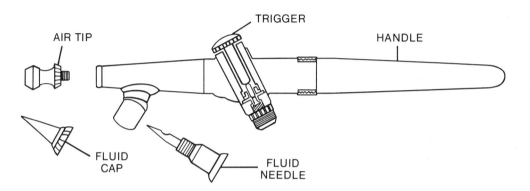

OPERATION: The SINGLE-ACTION, EXTERNAL-MIX airbrush is triggered by simply depressing the trigger to release a preset volume of spray. Regulating the spray setting requires turning the FLUID CAP located at the front end of the airbrush (see expanded view), which increases or decreases spray volume.

SPRAY CHARACTERISTICS: The term EXTERNAL-MIX indicates that the air and liquid are brought together and atomized outside the head or FLUID NEEDLE ASSEMBLY of the airbrush. The fluid needle assembly consists of three parts: AIR TIP, FLUID CAP and FLUID NEEDLE. The FLUID NEEDLE, which the color is delivered through, is positioned inside the fluid cap (see expanded view). Most EXTERNAL-MIX, SINGLE-ACTION models also come equipped with INTERCHANGEABLE FLUID ASSEMBLIES.

EXTERNAL-MIX airbrushes produce a COARSE, STIPPLED spray pattern in comparison to the finer spray of internal-mix models. Another difference between the two types is the ability of the EXTERNAL-MIX to accommodate pigments of a heavier viscosity. Depending on the assembly size being used, external-mix airbrushes provide spray patterns which range in size from approximately 1/8" to 2-1/2".

APPLICATIONS: SINGLE-ACTION, EXTERNAL-MIX models have the most simplistic construction of the three airbrushes discussed. Generally speaking, this model is not used for finer types of rendering. The SINGLE-ACTION, EXTERNAL-MIX airbrush is the most popular model for CERAMIC work. Its ability to spray denser pigments and simplistic construction make this airbrush a practical tool for many ceramic applications.

AIRBRUSH MAINTENANCE

Proper maintenance of any airbrush demands that it be cleaned after every use. Pigment must NEVER be allowed to dry inside the airbrush's internal parts. Maintenance also requires correctly replacing and adjusting the parts once they have been removed for cleaning.

CLEANING: Cleaning procedures are approached in two basic ways: FIRST is to QUICKLY FLUSH the airbrush when CHANGING COLORS or before any break in spraying during your work period: SECONDLY, a more thorough CLEANING must take place concluding every work period.

The cleaning agent or solvent used for cleaning is determined by the type of pigment being used. The pigments recommended in this book are of a water-soluble nature and should be cleaned with an ammonia-based cleaning agent and water.

QUICKLY FLUSHING: Changing colors can be accomplished quickly by detaching the color jar from the airbrush and replacing it with another filled with cleaner. Spray the cleaner at a heavy spray setting into a paper towel or similar material until the airbrush is flushed free of color. Next, remove the jar of cleaner and spray the excess cleaner from the airbrush. Conclude by replacing cleaner with the next color. Should a COLOR CUP be used instead of JARS, simply wash the cup and proceed as described above. Flushing is also recommended BEFORE INTERMITTENT BREAKS during your work period. A good habit to develop is to quickly flush your airbrush before it is allowed to stand idle (after spraying) for more than a few minutes. Flushing can be approached in basically the same way with all three types of airbrushes.

THE THOROUGH CLEANING: Concluding every work period the airbrush must be partially dismantled and thoroughly cleaned. This process begins by flushing the airbrush as you would for changing colors. Once the flushing is completed, remove and clean ONLY THOSE PARTS which come into CONTACT with PIGMENT. It is NOT NECESSARY to dismantle the entire airbrush.

The basic parts cleaned when using the internal-mix models are the head assembly and needle. The external-mix models require cleaning the fluid needle assembly. This procedure is somewhat different with each airbrush type as a result of the different configurations of parts. Individual makes of airbrush will also vary to some extent even when comparing airbrushes of the same type. This is why the manufacturer's INSTRUCTION MANUAL is an invaluable reference guide for correctly cleaning and maintaining your airbrush. When cleaning, it is helpful to have an old toothbrush, pipe cleaner and cotton swabs.

After the airbrush parts have been removed and cleaned, they must then be carefully replaced and adjusted in their designated positions. Failure to align each part correctly will prevent the airbrush from functioning properly. In many instances, when an airbrush fails to perform correctly, the blame is accredited to a faulty airbrush. Much of the time these problems result from IMPROPER CLEANING or ALIGNMENT OF PARTS.

Study the INSTRUCTION MANUAL thoroughly and always CLEAN your airbrush after each use. Doing this will greatly minimize frustrating and UNNECESSARY problems that plague many a would-be airbrush artist.

AIR SOURCES

Two basic types of AIR SOURCES are utilized to provide the airbrush with air: COMPRESSORS and COMPRESSED GAS. The air source must provide a minimum of 1/2 c.f.m. (cubic feet per minute) of air at a setting of 25-30 p.s.i. (pounds per square inch) to accommodate one airbrush.

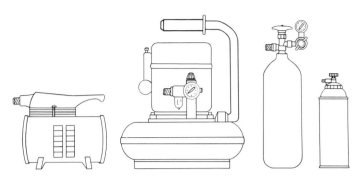

DIAPHRAGM COMPRESSORS are portable, oilless, use 110v house current and are usually maintenance-free. Most provide a nonpulsating spray; however, the noise and vibration level will differ with various makes and models. An average DIAPHRAGM COMPRESSOR provides approximately 1 c.f.m. at approximately 25 p.s.i. and is designed for use with only one airbrush.

It is important that the compressor be SELF-BLEEDING. "Self-bleeding" refers to the compressor's automatic release of excess air; that is, when the airbrush is not in use and the motor is left running, excess air is automatically allowed to escape.

Some models of this type have an AIR-ACTIVATED AUTOMATIC SHUT-OFF SWITCH built into their motor. This will simultaneously activate the compressor as the airbrush is triggered. Upon release of the airbrush trigger, the compressor will automatically shut off. This convenient feature prevents overheating and prolongs the life of the compressor. Diaphragm compressors not equipped with automatic shut-off switches should not be run for more than forty-five minutes at a time. Note: Diaphragm compressors are relatively inexpensive in comparison to piston models. Models equipped with the air-activated automatic shut-off switch are preferred.

PISTON COMPRESSORS: Generally, compressors of this type provide a higher volume of air than do the diaphragm types. This allows more than one airbrush to be accommodated and also permits the use of a SPRAY GUN which requires HIGHER c.f.m.

Piston compressors are typically mounted on STORAGE TANKS which store the compressed air. The compressor builds up air pressure to a preset pressure setting and then automatically shuts off. The airbrush then feeds from the storage tank. When the air pressure drops to a lower pre-determined setting, the compressor is automatically reactivated. A major disadvantage of piston compressors in past years was the great amount of noise they produced. This is no longer a problem; highly efficient, SILENT piston compressors are now available.

COMPRESSED GAS: The COMPRESSED GAS TANK is another method of providing air. It is also silent and, until the development of silent piston compressors, was the only noise-free air source.

CO_2 is most commonly used as a propellent; however, nitrogen, which is totally moisture-free, is preferred. The gas TANK may be rented and refilled from suppliers of oxygen and acetylene. The tank must be equipped with a REGULATING GAUGE designed for the high pressure of compressed gas tanks. Especially when using nitrogen, COMPRESSED GAS TANKS provide a clean, dry and silent source of air.

PROPELLENT CANS: The small aerosol cans used to propel the airbrush are simply disposable versions of the larger gas tank. When using propellent cans, a PROPELLENT REGULATOR must first be attached to the can. The airbrush hose can then be attached to the regulator.

There are several disadvantages to using propellent cans. First, as you spray, the liquid in the can evaporates, chilling the metal container which in turn drops the air pressure. Full pressure will not return until the can returns to room temperature. Also, the life span of a propellent can is very short; regular use becomes inconvenient and expensive.

AIR LINES AND FILTERS

AIR LINES: The AIR LINE or HOSE should be a sufficient length for your convenience. A 15 foot braided hose is a practical choice for most airbrush set-ups; longer lengths are available.

AIR FILTERS: Compressors develop moisture which can pass through the air hose and damage art work. This is especially true of piston compressors that can also accumulate oil in their air storage tank.

The BETWEEN-LINE FILTER is attached directly to the compressor before attaching the air hose. The hose is then attached directly to the filter, fitting BETWEEN the air source and air line. Smaller IN-LINE FILTERS are also available for splicing directly into the air hose.

PISTON COMPRESSORS are best equipped with BOTH types of filters. DIAPHRAGM TYPES require only the smaller IN-LINE FILTER. GAS TANKS, especially those containing nitrogen, are not generally used with filters; however, the IN-LINE filter is suggested for use with all air sources.

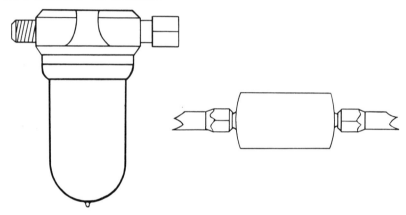

STUDIO VENTILATION

Working in a well-ventilated room is first and foremost for the airbrush artist. A lightweight dust mask or respirator should be used when spraying heavily for long periods or when using a spray gun.

Exhaust fans mounted in windows or a spray booth equipped with an exhaust fan are often used to remove overspray from the studio. Air purifiers designed with the airbrush artist in mind are also available for removing particles from the air. These devices are relatively inexpensive, small and may be implemented where an exhaust system is impractical.

MEDIA, MATERIALS AND MISCELLANEOUS EQUIPMENT

Newcomers to airbrush technique often experience unnecessary problems which result from choosing an inappropriate combination of materials. The type of MEDIUM sprayed and the PAINTING SURFACE it is sprayed on are factors that must be considered before painting begins. A third consideration is the type of material used to make the STENCIL.

Correctly choosing the right combination of **PIGMENT, PAINTING SURFACE** and **STENCIL MATERIAL** will eliminate frustrating and unnecessary damage to art work.

MEDIA

INK, DYE, CERAMIC GLAZE and PAINT of any type can be sprayed through an air-brush if mixed to the proper viscosity. The viscosity generally used for airbrush medium can be compared to that of heavy cream or slightly heavier than ink. All color intended for airbrush use must be thoroughly liquified, or clogging and spitting of solid material can occur.

WATER-SOLUBLE PIGMENTS: Although any type of material can be sprayed through an airbrush, some are more desirable than others. For example, water-soluble pigments are typically easier to clean, dry faster and are safer to use than non-water-soluble types. WATERCOLOR, GOUACHE and ACRYLICS are some of the water-soluble pigments most commonly used in airbrush painting. A variety of COMMERCIALLY PREPARED, PRE-REDUCED AIRBRUSH PIGMENTS are also of a water-soluble nature.

NON-WATER-SOLUBLE PIGMENTS: LACQUERS, ENAMELS and OILS are thinned and cleaned with thinners of a compatible chemical base. Lacquers and enamels are primarily used in automotive painting or any work intended for outdoor use. These pigments are more difficult to use and require appropriately ventilated work areas. Oils take considerable drying time and are impractical for most airbrush applications.

WATERCOLOR: Watercolor is a good airbrush medium in that it sprays well and cleans easily. It is cleaned from an airbrush with water or ammonia-based cleaning agents. Note: It should be understood that when color is applied by spraying, even opaque pigments create a transparent effect. Watercolor and other transparent mediums may be inappropriate for developing intense values.

GOUACHE: Gouache is actually opaque watercolor. It is water-based and is also cleaned with water and ammonia cleaners. Gouache is useful in photo retouching where it may be necessary to manipulate or even remove sprayed pigment from the photographic surface after it has been applied. It also has an extremely opaque quality which easily covers unwanted areas of the photograph. The opaqueness can also be used for adding intense highlights directly over dark areas.

INKS: Generally, inks are water-soluble and cleaned with water and ammonia-based cleaning agents. One disadvantage of many inks is their quick drying time. This can result in a dry build up of material at the end of the airbrush needle. Ink is, however, a relatively good airbrush medium.

ACRYLIC PAINT: Acrylics are a popular airbrush medium, especially for use on canvas. When reduced and cleaned properly they can be used in the airbrush with great success. However, standard artists' acrylics are not recommended for the beginner. Give yourself adequate time to fully understand the cleaning and maintenance of your airbrush before using acrylics. Jar color rather than tube color is recommended for easier mixing and finer consistency. A standard mixture for reducing acrylics follows:

1. Mix together equal parts of ACRYLIC GLOSS MEDIUM and WATER.

2. Then mix one part of the mixture per one equal part of PAINT.

DO NOT use MATTE medium for the mixture; it will dull the color. When a matte finish is desired, simply apply a coat of matte medium once the painting is completed.

Acrylics must always be thoroughly cleaned from the airbrush with an ammonia-based cleaning agent and water.

CERAMIC GLAZES: Self-prepared glazes must be ground, thinned and mixed to a compatible viscosity for airbrush work. Many commercially prepared ceramic materials have a smooth consistency which can be thinned with water and sprayed easily.

DYES: Dyes are often used for tinting and coloring photographs and also in some textile applications. They are a more specialized medium and not recommended for general airbrush work.

TEXTILE PIGMENTS: Specially formulated for textile applications, commercially prepared, pre-reduced textile pigments are available to accommodate the airbrush. This type of pigment must be heat-set after it has been applied. When selecting a textile pigment, be certain it is water-soluble, pre-reduced and designed for airbrush use. PRE-REDUCED TEXTILE PAINT is RECOMMENDED for airbrushing on all textile surfaces.

COMMERCIALLY PREPARED, PRE-REDUCED AIRBRUSH PIGMENTS: Pigments have been developed specifically to be used in conjunction with the airbrush. Most have a fine acrylic base and are water-soluble. They are produced by several manufacturers and are available in both opaque and transparent finishes. It is RECOMMENDED that opaque PRE-REDUCED AIRBRUSH PAINT be used for all exercises in this book. These convenient, ready-to-use pigments are always consistent in viscosity and liquidity and less likely to clog the airbrush. Many of these pigments also have their own specially formulated ammonia-based cleaning agents.

A BASIC SET OF AIRBRUSH COLORS should include yellow, red, blue, green, chrome oxide green, sepia, white and black. These pigments can be intermixed to create any variation of color. Most manufacturers of pre-reduced airbrush paint have many variations of color to choose from other than those found in a basic set. A broad selection of color is a convenience in that it eliminates mixing.

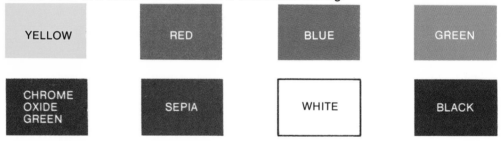

PAINTING SURFACES

The type of material selected to paint on is another important factor for successful airbrushing. The adhesive material used for stenciling and masking can damage the painting surface and/or lift sprayed color from that surface. The following suggestions provide basic guidelines for choosing painting surfaces.

PAPER AND ILLUSTRATION BOARD: Both paper and board have two basic surfaces to choose from: HOT and COLD PRESS.

HOT PRESS: These surfaces are relatively smooth in comparison to cold press. Smooth surfaces provide more surface area for adherence of stenciling materials. This can promote tearing or lifting of some hot press surfaces.

COLD PRESS: Paper and boards of this type have more texture, which permits less surface area for adherence by the stenciling materials. When choosing cold press surfaces, keep in mind that the texture of the material affects the texture of your spray.

There are several manufacturers of paper and illustration board who have developed surfaces specifically for use with airbrush technique. Available in HOT and COLD PRESS surfaces, both will withstand the rigors of stenciling. Be sure to ask your dealer for products that are suitable for airbrush work.

A DRAWING PAPER PAD, 11" x 14" or 14" x 17", medium cold press, two-ply, and 100% cotton rag is RECOMMENDED. This should be used for the beginning exercises, practice and experimentation.

For more extensive paintings you may wish to use illustration board or high grade airbrush paper. Again, ask your dealer for products suitable for airbrush painting and EXPERIMENT with a wide range of painting surfaces. A pad of TRACING PAPER for preliminary LAYOUTS will also be necessary.

CANVAS: Canvas can consist of cotton or linen. Linen is generally of a higher quality and has fewer manufacturing flaws than cotton. Canvas is available in either unprimed or pre-primed surfaces. Unprimed material must be prepared with several thin coats of acrylic gesso and lightly sanded between coats. High quality pre-primed canvas has a relatively good surface for airbrushing and eliminates time-consuming preparation, however, pre-primed canvas is more difficult to stretch.

GESSOED BOARDS: UNTEMPERED MASONITE or commercially-prepared CANVAS BOARD may be primed with acrylic gesso for a compatible airbrushing surface. As described for unprimed canvas, both masonite and canvas board must be gessoed and sanded between coats.

STENCILING MATERIALS

TAPE, FRISKET, ACETATE, WAXED STENCIL PAPER, and commercially-prepared LIQUIFIED STENCILING SOLUTIONS are the major materials used for stenciling and masking. Stencil materials can be categorized as either SELF-ADHERING or NON-ADHESIVE types. Self-adhering materials such as tape, frisket and liquid stencil solution adhere directly to the painting surface. The non-adhesive types such as stencil paper or acetate require taping or weighting the stencil to your painting surface.

TAPES: DRAFTING and MASKING tapes are available in a variety of sizes and intensities of TACK. The tack refers to the material's adhesive strength. DRAFTING TAPE has a lower tack than masking tape and is less likely to damage paper or illustration board surfaces. MASKING TAPE is better suited for work on gessoes surfaces which call for a stronger tack.

FRISKET: Frisket is made of transparent paper or vinyl film. Both types come prepared with a fine adhesive on one side which is protected by a removable backing. VINYL FRISKET FILM is preferred, paper becomes brittle with age and tends to tear when removed.

Vinyl frisket film is available with either matte or gloss finishes. The matte finish surface tends to accept pencil drawings and transfers better than gloss finish frisket.

When working on canvas or other gessoed surfaces, common household CONTACT PAPER can be used in place of frisket. This material has a much stronger tack in comparison to frisket and will adhere to large areas of canvas when some frisket films will not. Most varieties come in an opaque color or pattern; however, a few can be found in a clear vinyl. Contact paper must be used with CAUTION and should be thoroughly tested prior to use. Never use contact paper on paper or illustration board.

LIQUIFIED STENCILING SOLUTIONS: Commercially-prepared stenciling solutions, similar in consistency and character to rubber cement, are also used for stenciling. This material is usually applied to the surface with a paintbrush. When dry, the solution becomes moisture-resistant and blocks out the selected surface area. Removing this material is accomplished by lifting it gently with a RUBBER CEMENT ERASER or piece of tape. Care must be taken not to damage the surrounding sprayed surface when removing the dry solution.

Solutions of this type should be applied to the painting surface before airbrushing. Placing them over sprayed pigment may discolor painted areas.

ACETATE: Acetate is a clear plastic film which does not have an adhesive backing. WET MEDIA acetate opposed to the standard material has a slight tooth for greater adherence of pigment. This prevents the paint from beading up and rolling off the stencil onto your work. Also, the tooth makes wet media acetate a good painting surface. It is often used in photo retouching as an overlay. The retouching is done on the acetate overlay rather than the photo itself. When the overlay and photo are rephotographed together, the camera will not record any difference between the two surfaces.

PAPER: Commercially-prepared waxed STENCILING PAPER or any stiff, durable paper material may serve as a stencil. Manila paper, similar in weight to a file folder, is a reasonably good material for stenciling.

MISCELLANEOUS EQUIPMENT

Aside from the AIRBRUSH and AIR SOURCE, there are several other tools used to aid and support airbrush technique. Many tools such as T-squares, pencils and paintbrushes are common items used in practically every painting application.

(Figure 1)

CUTTING TOOLS: Stencil knives are one of the most extensively used tools in airbrush technique. **STENCIL KNIVES** (with interchangeable blades of different shapes), **NEEDLE TOOLS** and **SWIVEL KNIVES** all have various uses for cutting stencils. The standard STENCIL KNIFE pictured first *(Figure 1)* is by far the most versatile and popular stencil-cutting tool. SWIVEL KNIVES can be helpful when cutting curves and circles. The NEEDLE POINT tool is used in conjunction with plastic FRENCH CURVES or drafting templates. This device will not cut into the edge of the plastic as a blade can.

(Figure 2)

The **T-SQUARE** and **TRIANGLE** are basic tools which provide square borders and general preciseness.

A **METAL RULER** serves as a rigid guide for making straight cuts.

(Figure 3)

A **FINE SABLE PAINTBRUSH** will be necessary for detailing or touch-ups and a **STIFF BRISTLED BRUSH** can be used for mixing pigments. A separate brush should be used for applying liquid stenciling solution.

For achieving neat, clean preliminary drawings, a **2-H DRAWING PENCIL** and **KNEADED ERASER** are required.

A **RUBBER CEMENT ERASER** is useful when removing liquified stenciling solution.

(Figure 4)

A basic **DRAFTING KIT**, including a **COMPASS** with cutting/ruling pen ATTACHMENTS and a **RULING PEN** for outlining or cleaning up edges, is RECOMMENDED. These tools are not mandatory for completion of the projects in this book. They will, however, give circles and outlined forms a more precise and professional look.

(Figure 5)

A draftsman's **DUST BRUSH** can be useful for removing overspray, eraser crumbs and other debris.

The portable **UPRIGHT DRAWING BOARD** is a convenient support for the painting surface.

(Figure 6)

SQUEEZE BOTTLES filled with cleaner and water are a convenience when flushing the airbrush. They can also be used for storing and dispensing pigments.

A flexible plastic water **BUCKET**, used in cleaning, is easily cleaned and inexpensive.

A PALETTE for mixing paint will also come in handy.

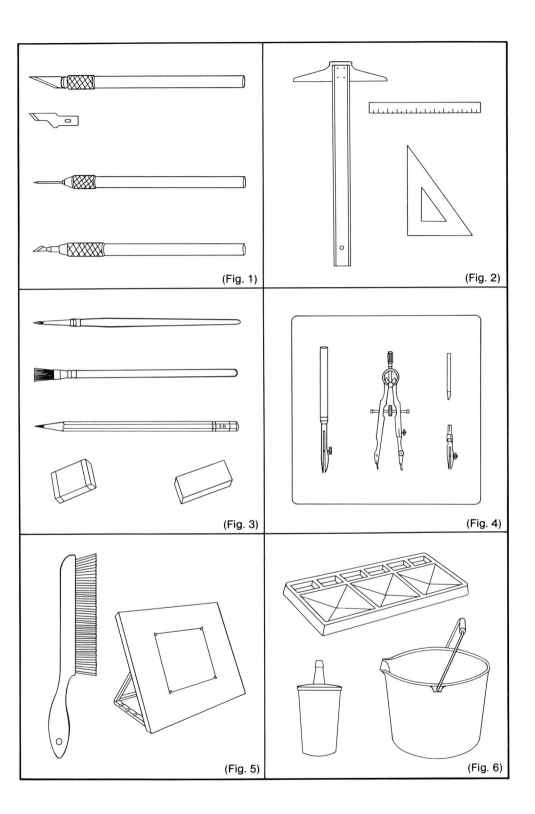

(Fig. 1)

(Fig. 2)

(Fig. 3)

(Fig. 4)

(Fig. 5)

(Fig. 6)

19

PREPARATION FOR AIRBRUSHING

HOOKING UP: Hooking up the airbrush is yet another area which requires the manufacturer's instruction manual. It will point out the specific procedure most appropriate for attaching the air hose to air source and the airbrush to air hose.

The standard AIRBRUSH HOSE has a 1/4" female pipe fitting attached to one end and a smaller coupling on the other. The larger fitting must FIRST be screwed onto a male pipe fitting which extends from the air source or air filter. TEFLON PIPE TAPE found at most hardware stores can be wrapped around the male pipe fitting before attaching the hose. This assures an airtight seal. Begin tightening pipe fittings by hand and finish the attachment with a wrench (do not over-tighten).

NEXT, the smaller coupling at the opposite end of the hose is attached to the airbrush. Screw the airbrush down into the coupling, getting the threading started correctly. Then tighten the coupling securely to the airbrush by hand. The small wrench included with your airbrush is then used for a final "light" tightening. Over-tightening any fitting on either the airbrush or air source can cause damage to the threading.

POSITIONING OF THE PAINTING SURFACE: Airbrushing may be done on a horizontal, vertical or slanted surface. Size of work and type of stencil technique used are two factors which determine the positioning of the painting surface.

Larger painting surfaces such as stretched canvas are usually placed vertically or at a slight angle for easy access to all areas of surface.

Adjustable DRAWING TABLES and EASELS are commonly used for supporting air-brush painting surfaces. An inexpensive and portable structure for supporting the painting surface is the UPRIGHT DRAWING BOARD. Begin airbrushing with the surface in a SLIGHTLY SLANTED position and experiment with a variety of positions as you advance. Taping the paper to a heavy illustration board or old drawing board during the painting process is recommended. This will keep the material secure and flat.

MASKING OFF BORDERS: In many of the upcoming exercises you will mask off a border surrounding the area to be painted. The area or SPACE within these borders is referred to as the PICTURE PLANE.

(Figure 1)

Masking off a border can be accomplished by simply taping along the outer edge of your paper. In addition to producing a border, taping keeps the surface flat and secure on the drawing board.

(Figure 2)

For the beginning exercises, a strip of tape along the top and bottom of the paper is sufficient.

(Figure 3)

For a wider border, pieces of scrap paper may be taped down to the edge of the picture plane. When using this method, the border's edges should be taped off first. The paper is then taped to the border of tape.

DEVELOPING LAYOUTS AND TRANSFERRING THE DRAWING

Producing a successful airbrush rendering usually requires beginning with a sharp, linear drawing or LAYOUT. Developing your IMAGES and layout on TRACING PAPER rather than the actual painting surface is always advised. The subtlety of airbrush work does not allow for erasing, redrawing and the general rigorous contact necessary for developing a final layout.

PICTURE FILES: Many artists in both the graphic and fine arts areas keep picture files of magazine clippings and photographs. Tracings made from this type of material can be pieced together with other drawings to create a composition.

OPAQUE PROJECTOR: OPAQUE PROJECTORS are a great convenience for ENLARGING images from books or photographs. Some more expensive projectors REDUCE images as well as enlarge them.

SQUARE GRIDS: Another means to enlarge an image is the SQUARE GRID method. Simply superimpose a grid of small squares over a drawing and then copy each square into another grid of larger squares. This method is certainly not as quick as employing a projector; however, it does work well.

LIGHT BOXES: LIGHT BOXES or TABLES can be used to cut a frisket stencil placed directly over a layout with bristol board sandwiched between the frisket and layout. With the frisket on top of the cutting board and the layout beneath, the light provides the ability to view the layout to be cut.

Should you use only one or a combination of the methods described, the final layout should be a clean, clear, linear drawing. Once the layout or drawing has been completed to satisfaction, it must then be transferred from the tracing paper to the surface.

1. Using a 6B lead pencil, thoroughly trace over the BACK SIDE of the drawing to be transferred.

2. Next, rub the graphite into the tracing paper with a paper towel, cloth or cotton. This will prevent loose, excess graphite from soiling the painting surface.

3. The drawing is now ready to be transferred. Place the graphite side or the back side of your drawing in contact with the surface it is to be transferred on. Once in place, secure it with a few pieces of masking tape.

4. Conclude by carefully tracing over the entire drawing with a hard lead pencil, transferring it from the tracing paper to the surface.

In some of the exercises you will be instructed to first place the matte finish frisket film onto the blank painting surface. This will be followed by the transfer of your drawing onto the frisket film. Note: This sequence avoids placing the drawing directly on the painting surface, which in turn eliminates a possible problem with the drawing showing through the sprayed color.

In some cases, however, the drawing must be transferred directly onto the painting surface. For example, when remasking sprayed areas in a complex composition, it may be necessary to apply an entirely new piece of frisket and recut the completed areas. This is a result of the difficulty involved in correctly re-registering intricate stencil parts. Should you intend to replace your frisket during the painting sequence, the drawing must be transferred onto the painting surface. This eliminates the need to transfer the drawing a second time on the second piece of frisket film.

Also note, all stencils should be cut before airbrushing begins. If you were to begin spraying before cutting the entire stencil, the color would block the drawing from view. Double check the stencil to be sure all of the stencil has been cut before you begin spraying.

BASIC TECHNIQUES

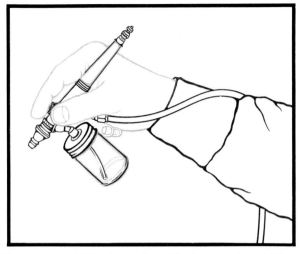

(Figure 1)

HOLDING THE AIRBRUSH:
The airbrush is held in the same basic manner as a pen or pencil. The index finger is placed on top of the trigger with the airbrush hose draped over your forearm, keeping it clear of the painting surface. Whether your painting surface is placed in a vertical, slanted or horizontal position, the airbrush is held PERPENDICULAR to the surface. Holding an airbrush correctly is a very simple yet most important aspect of operating this tool. The airbrush should feel comfortable in your hand. The hand and arm should not be tense. A smooth, consistent movement is necessary when spraying.

DETERMINING THE DISTANCE BETWEEN THE AIRBRUSH AND PAINTING SURFACE: The distance between the airbrush and surface is determined by the volume of color being sprayed. When regulated to a reduced setting, the airbrush is positioned closer to the surface, thus spraying a finer pattern. As the setting is increased, the distance of airbrush from that surface must also be increased. When airbrushing too close to the painting surface at a heavy spray setting, puddles of pigment will quickly form and spread (see page 24, *Figure 3*).

TRIGGERING THE AIRBRUSH: As described earlier, when using a SINGLE ACTION airbrush, simply push down on the trigger.

The DOUBLE ACTION requires depressing the trigger and drawing back. Begin triggering in the off position before pulling back. This assures you of getting only the amount of spray desired.

MOVEMENT OF THE HAND: Hand movements are accomplished by moving the entire arm. Moving only your hand and wrist will create a feathering effect at both ends of the spray pattern and generally make it more difficult to direct the spray pattern.

The hand movement begins before depressing the trigger and continues or follows through after it has been released. This method prevents hesitations as you begin and end the spray pattern. Hesitating while spraying will produce a build up of pigment as shown on page 25, *Figure 5*. When spraying, the airbrush must be kept in motion.

CORRECT HAND MOVEMENT: Airbrush a straight and consistent spray pattern:

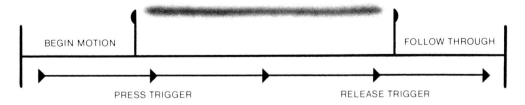

BEGIN MOTION FOLLOW THROUGH

PRESS TRIGGER RELEASE TRIGGER

Keep a steady movement with no hesitations.

AIRBRUSH CONTROL EXERCISES

Exercises 1 through 3 will develop control and confidence in basic airbrush operation. Development of these basic skills is essential for a serious learning experience to occur. Take the time to practice each exercise thoroughly.

Note: As you practice the exercises, keep a sheet of scrap paper handy for testing the airbrush. Also, use BLACK pigment until color is requested.

EXERCISE ONE:

(Figure 1)

Begin by lightly penciling a grid of one inch squares. Holding the airbrush approximately 1/2" from surface, spray small dots where the lines intersect. Accuracy of placement and consistency of dot size is the objective in this exercise.

(Figure 2)

Next, enlarge the size of each dot by increasing the spray setting.

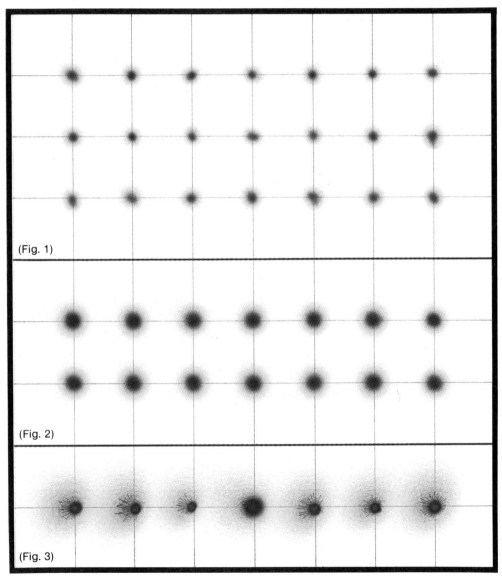

(Fig. 1)

(Fig. 2)

(Fig. 3)

(Figure 3)

Airbrushing too close to surface for the volume of color being sprayed.

EXERCISE TWO:

(Figure 4)

Airbrush fine lines, left to right. Holding the airbrush approximately one inch from surface, spray several straight lines using CONTINUOUS hand movements. Hesitating while spraying forms a build-up of color at either end of spray pattern *(Figure 5)*.

EXERCISE THREE:

(Figure 6)

As in Exercise 1, pencil a grid of one-inch squares. Airbrush small dots of consistent size where the lines intersect. Proceed by connecting the dots with straight lines of an even tone. Exercises 2 and 3 develop proper hand movement.

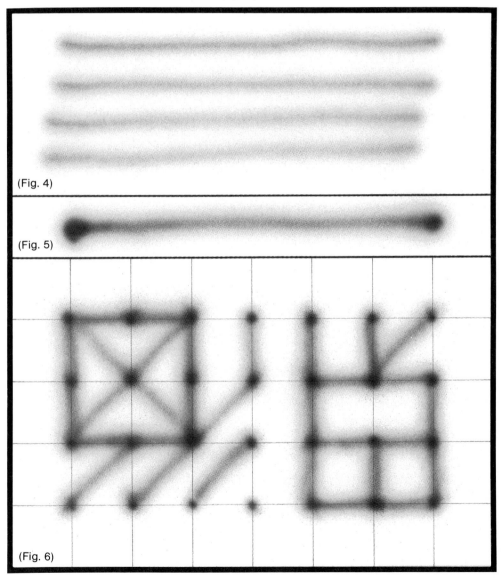

(Fig. 4)

(Fig. 5)

(Fig. 6)

TONAL VALUE EXERCISE

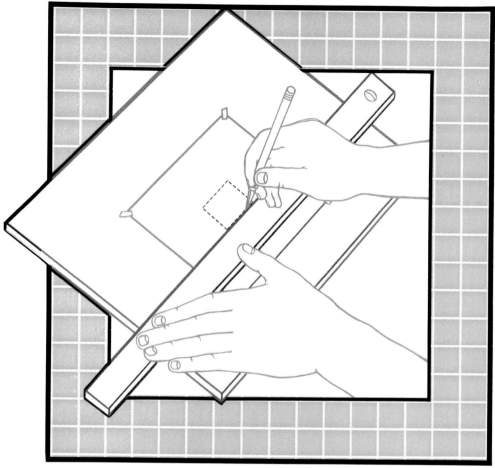

(Figure 1)

This illustration shows the cutting of a paper stencil. A stiff paper such as a file folder can be used. Using the stencil knife and metal ruler, cut out a two-inch square, leaving at least a three-inch border surrounding the opening.

(Figures 2, 3, 4, 5)

The next step is to pencil a grid of two-inch squares (three squares down and three across). Position the paper stencil over the first top square (working left to right). The objective is to airbrush a tone which smoothly graduates from dark to light. The spray pattern should be directed toward the corner of the stencil, not the painting surface. Do not allow the tone to reach the center of each square. Working across the page, continue airbrushing the bottom corner of all the squares. Build each tone slowly and remember to aim the spray at the very corner of the stencil.

(Figures 6, 7)

The page is now turned upside down and the stencil repositioned. The exercise is concluded by spraying the opposite corner of each of the squares. Once completed, each square should look consistent in tonal value.

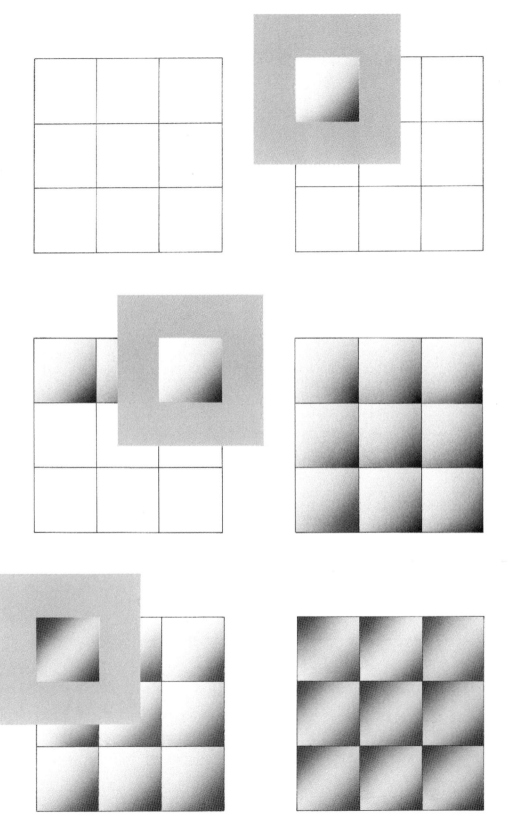

GRADUATED TONE EXERCISE

The objective here is to develop the ability to airbrush evenly-graduated tones. The tone begins with an intense black at the top of the page and gradually and consistently blends into only the white of the paper itself.

(Figure 1)

Position the airbrush approximately six inches from the surface. Spray overlapping passes, starting at the top of paper and working gradually towards the bottom. When approximately three-quarters of the page has been covered with a light gray, stop spraying and REPEAT the process several times.

(Figures 2, 3)

As each step is completed, do not spray quite as far down the page as in the previous step.

The tone is built up slowly and consistently through a series of spray passes.

Should the pigment appear glossy and wet on the painting surface, it is indicating that too much pigment is being sprayed. This can also mean that you are spraying too close to the surface.

This simple exercise relates directly to almost every aspect of airbrush rendering. It is recommended that this procedure be repeated periodically as you proceed. Again, develop tones slowly and consistently.

THE BASIC DRAFTING KIT

A basic mechanical drafting kit can be helpful in many areas of airbrush technique. A DRAFTING KIT (as shown on page 19) should include a COMPASS with ruling pen/cutting attachments and a RULING PEN. Note: the ruling pen must be used in conjunction with a RAISED EDGE RULER. The raised edge prevents the pigment from running underneath the ruler and smearing. Commercially prepared airbrush paint or ink is the suggested medium for use in the ruling pen and ruling pen attachment. Liquified stenciling solution or reduced rubber cement may also be used. Note: The grid below was produced by first applying stenciling solution with a ruling pen. Color was then airbrushed over the dry stenciling solution. After the color was sprayed, the dry solution was removed leaving the white of the page to create the grid.

There are several ways to use a compass aside from drawing circles. The CUTTING ATTACHMENT can be used to cut precise circles from your stenciling materials (see page 30). With the RULING PEN ATTACHMENT it can also be used to draw circles with a liquid medium as shown below.

The RULING PEN and RAISED EDGE RULER produce precise lines in various widths. The width of line is varied by adjusting the blades of the pen with it's ADJUSTMENT NUT. The pen can be filled with an eye dropper or a small paintbrush. Wipe the excess color off the outside of the blades before using. The ruling pen can be used to outline forms for contrast or to clean up a rough edge after removing a stencil.

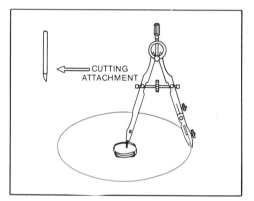

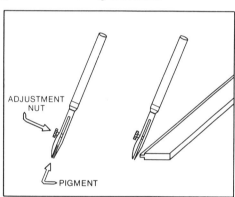

3-D RENDERING EXERCISES

The methods used in the previous exercises will now be implemented to render three geometric shapes. The exercise begins with important information concerning frisket and acetate stenciling techniques. (Using the recommended drawing paper, tape down the top and bottom of the page for each of the three geometric shapes.)

SPHERE

(Figures 1, 2)

You are now ready to apply the vinyl frisket film over the drawing paper. Apply vinyl frisket film over the page by first peeling the backing from the frisket. Air pockets can be worked out to the edge of the film using the palm of your hand. Next, using your compass with the BLADE ATTACHMENT, cut a circle from the frisket film. To avoid damaging the paper with the compass needle, secure a coin wrapped with tape onto the frisket. Wrapping the coin with tape provides a soft material for the compass needle to pierce and adhere to. The coin is then attached to the frisket with double-sided tape. The circle can also be cut freehand with a stencil knife. The weight of the tool is usually sufficient pressure for cutting this material.

(Figures 3, 4)

The circle can be removed by placing the tip of the knife under the edge of the frisket and lifting. Begin to spray, directing the airbrush with a motion that follows the contour of the shape. Notice the light source comes from the upper right side as indicated by the arrow.

(Figures 5, 6, 7)

Spray overlapping passes that rotate in one continuous direction, building the tones slowly using a series of spray passes. As indicated by the arrow, the shadow is sprayed just inside the edge of the sphere, thus creating a highlight on its outer edge. When the rendering is completed, carefully remove your stencil. Do not leave frisket on your work overnight; the adhesive may begin to fuse to your paper. Frisket film stencils can be stored on the removable paper backing for future use but they are usually used only once.

 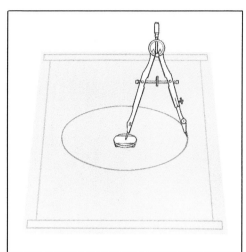

 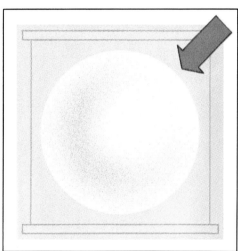

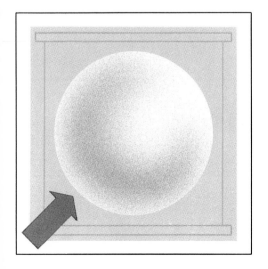 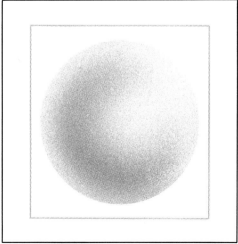

CYLINDER

This shape will be stenciled using nonadhesive acetate film. Unlike frisket stencils that are usually used once and discarded, acetate stencils are reuseable. Also unlike frisket, nonadhesive stencils must be secured to the painting surface. One method is to place any small, flat object such as a coin or metal printing typeface around the stencil to weight it down. A second method is described below.

(Figures 1, 2)

Using a 2-H pencil, draw a cylinder on a sheet of drawing paper. Cover the paper with a piece of acetate film and tape down the corners. You are now ready to score the material (it is not necessary to cut through the film). Begin by scoring over the entire drawing. Next, remove the acetate and bend it at the cut, separating the cut pieces. Should the acetate fail to separate when bent, re-cut it on a separate cutting board. A series of holes are then cut throughout the stencil using a PAPER PUNCH. Drafting tape is then placed over each hole. This will hold the stencil to the surface. The outer portion of the stencil is now returned to the paper. Once positioned, firmly press down on each tape-covered hole. Next, replace the bottom inside portion of the stencil as well.

(Figures 3, 4)

The arrow again points out the direction of the light source. Begin airbrushing the exposed top section of the cylinder. Notice the dark tones in the top are adjacent to lighter ones in the body below. This creates contrast which helps define and separate the two sections. Do not aim the spray DIRECTLY at the open edge of the stencil or you may lift the stencil from the painting surface. Aim the spray pattern over the stencil's edge. After the top has been painted, remove the lower portion of the stencil.

(Figures 5, 6, 7)

Before spraying the body of the cylinder it must be determined if it is necessary to remask the area just completed. A HARD EDGE which separates the top area from the bottom was created when the top was airbrushed. As a result it will not be necessary to remask the top while the bottom of the cylinder is airbrushed. Only a heavy opaque tone would overpaint or eliminate this hard edge which defines and separates the top and bottom. Continue by spraying the cylinder's body and remove the stencil.

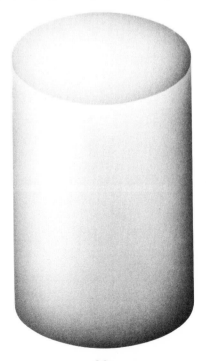

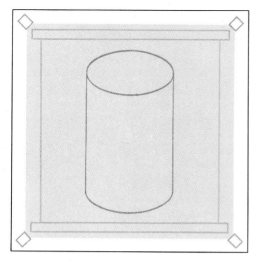
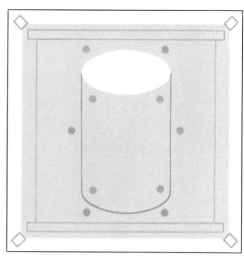
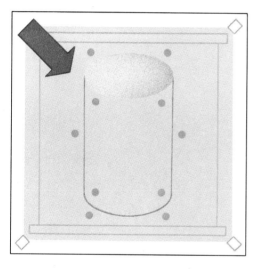
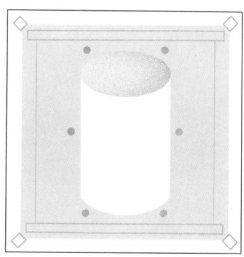
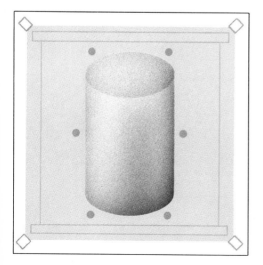
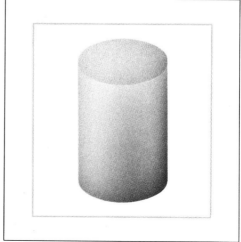

33

CUBE

Self-adhering frisket film will be used for stenciling this final shape. As in the previous exercise, no area will be remasked after it has been airbrushed. The painting sequence will begin with the darkest side or PLANE of the cube and proceed to the lightest. Each plane is defined with a different tonal value which creates the illusion of volume and depth.

(Figures 1, 2, 3)

Begin by placing a piece of matte finish frisket film over the paper. Proceed by drawing the cube on the frisket. As advised on page 22, drawing on the frisket rather than the paper will prevent pencil lines from showing through the spray. Using a metal ruler and stencil knife, cut along the perimeter of the cube and each of the inside lines which separate the three planes. The direction of the light source should now be determined before spraying begins. The lower right plane, which is exposed to the least amount of light, receives the darkest values. Proceed by removing the frisket which covers this portion of the cube. Begin airbrushing, aiming the spray at the edge of your stencil. Add a slightly darker value to the bottom and back of the plane; this will visually anchor the shape within your PICTURE PLANE.

(Figures 4, 5, 6)

When the darkest plane is complete, remove the frisket and spray the top plane which receives the middle values. The contrasting values define and separate the two planes. Proceed to render the top, keeping the overall values somewhat lighter than the first. When the top is finished, remove the frisket from the final side. Spray the final plane which is lightest in value and then remove the entire stencil. Do not remask any of the planes after their completion.

(Figure 7)

You have now completed the rendering of a cube without remasking between steps. When taking this approach, the entire shape must be painted the same color. Should you have chosen to paint one side of the cube red and the next green, remasking would be required. It is also necessary to work from dark to light when remasking is not employed between steps. Spraying the darker values first avoids overpainting the lighter sections of your work as you proceed through the spraying sequence.

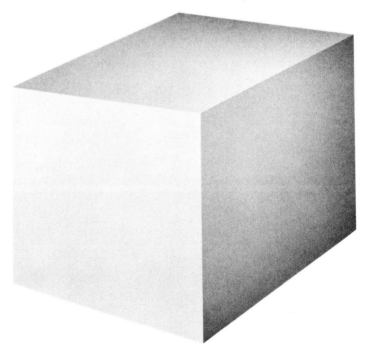

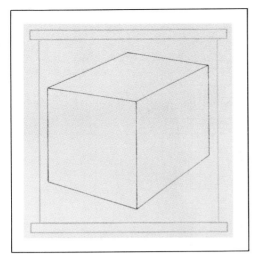
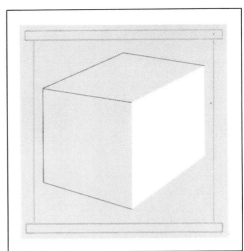
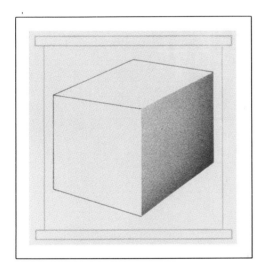
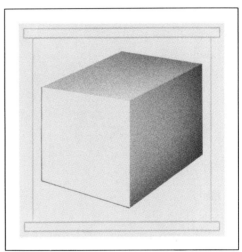
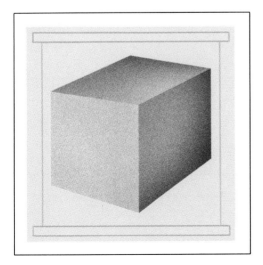

COLOR BLENDING EXERCISE

As you begin each of the following painting exercises, the size of your compositions must first be determined. **AS A GENERAL RULE, DOUBLE THE DIMENSIONS OF THE FINISHED ILLUSTRATION** concluding each exercise. Slightly varying the composition's dimensions from those recommended will not dramatically affect the results. You should, however, maintain the same proportions and not work smaller than the recommended dimensions.

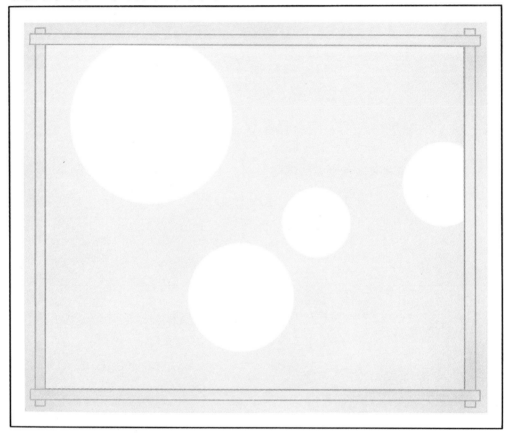

(Figure 1)

Begin by taping the painting surface to a drawing board or stiff matte board. Place matte finish frisket film over the painting surface. The spheres may now be drawn on the frisket with a compass. Cut each of the spheres with a stencil knife or, for a more precise cut, use a compass and cutting attachment as shown on page 31. Once the cutting has been completed, remove the internal portions of the stencil. Keep the stencil's parts for remasking. They may be stored on the frisket's protective backing.

(Figure 2)

Remember to aim the spray pattern at the edge of the stencil and not directly into the exposed page. Begin airbrushing the spheres with BLUE at the left side of each form. The light source which comes from the right of the composition is being established by first developing the shadows. RED is then sprayed to the right side of the forms, slightly overlapping and blending it into the blue. Notice the subtle blending of color as the blue and red are overlapped. Next, YELLOW is sprayed primarily into the red area with just a bit feathered into the blue. At this point, work back into the forms with more blue.

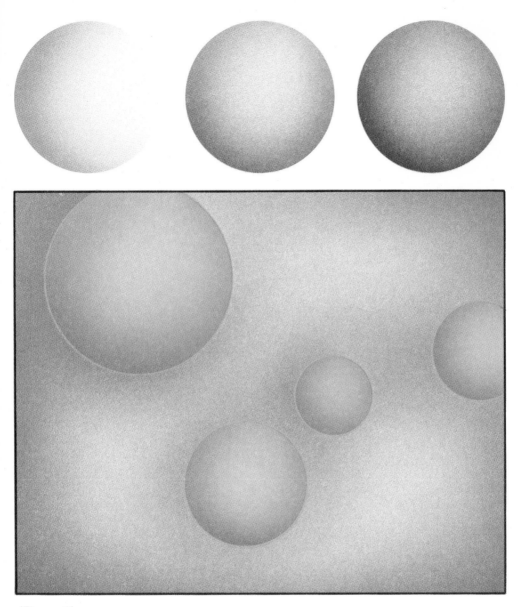

(Figure 3)

With the outer portion of the stencil still on the page, replace each of the internal stencil parts. (Be sure the pigment is thoroughly dry before replacement.) After each sphere has been remasked, slowly remove the outside portion of the stencil. The outer stencil is not removed until the remasking is accomplished; this provides a guide for replacing the inside stencils. You are now ready to airbrush the negative space or background. Again beginning with BLUE, spray several passes at the outer edges of the composition. Also add blue primarily to the left side of the spheres. Switch to RED, spray this color primarily to the right side of the forms, allowing it to subtly drift into the blue.

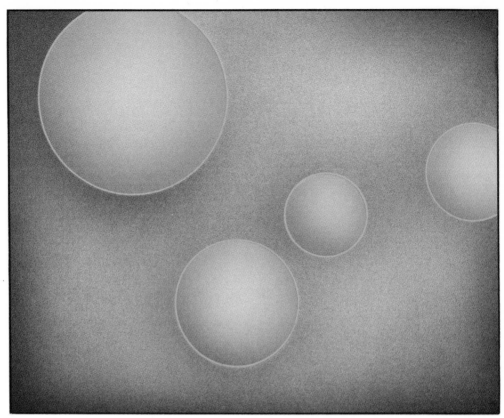

(Figure 4)

Continue spraying a bit of YELLOW, containing it to those areas initially sprayed with red. At this point the entire sequence of colors is re-sprayed, from blue to red to yellow. Again, work slowly, building and developing the overall color scheme by slightly overlapping and blending one color into another. Once the sequence has been repeated, spray a very limited amount of BLACK toward the outer edges of the page. Allow a little of the black to drift into the predominantly blue areas as well. Use the black sparingly; it is extremely easy to dull and darken the color undesirably when using black.

Note: The major objective in this exercise is simply to familiarize you with blending and overlapping color. The airbrush's ability to apply color in a transparent manner (as described in the introduction) should be evident upon completing this exercise. Take the time to experiment with several different color combinations. Cut a sphere from a piece of acetate to create a reuseable stencil. Airbrush the sphere many times using different color combinations and also spraying the same colors in a variety of sequences. Make a notation next to each sphere indicating the colors and sequence used and keep them for future reference.

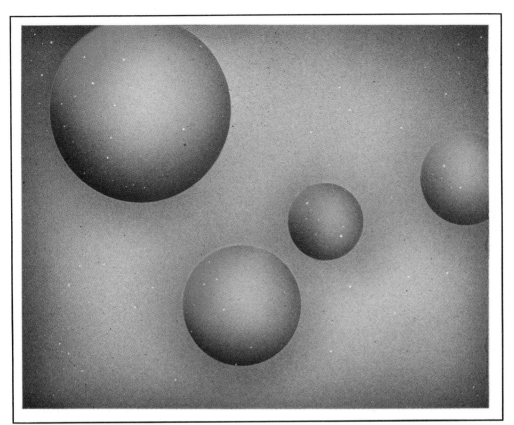

(Figure 5)

Once the hue of colors reaches the desired level, stop spraying and remove the frisket from the spheres. To conclude, a heavy stipple will be placed over the entire composition. This can be accomplished in a few different ways. Lowering the p.s.i. to 15 pounds and experiment with a variety of settings, both higher and lower. Assuming you cannot regulate the p.s.i., crimp the airline to cut back the pressure. Thinning the pigment will also create a stipple; however, it cannot be controlled as well as lowering the p.s.i. Splattering color with an old toothbrush is yet another means of producing a stipple. A combination of a low pressure setting and a toothbrush was used in *Figure 5*. The colors used include RED, BLUE, GREEN and a majority of WHITE.

PETER WEST
TRI-VIEW
Acrylics on plexiglass 12" x 36".

(Fig. 1)

COMMON OBJECT STENCILS

Stencils are primarily used to block out pre-determined sections of the painting surface from the spray. Other selected areas are left exposed for painting. This is how the contour of a form takes on its specific shape. Implementing a stencil to create a form usually requires the use of frisket film, acetate or stencil paper. A stencil, however, can be defined as ANY MATERIAL or OBJECT placed between the painting surface and the spray. COMMON OBJECTS such as thumb tacks, pebbles, paper clips, cloth or metal mesh may all be used in stenciling. These types of materials are especially helpful for producing textures and patterns.

The following list of common objects and brief descriptions were used to create the effects shown in *Figures 1 through 6*. All of the objects listed have been used in conjunction with a circular, pre-cut acetate stencil. Each item is placed over or inside the main stencil, producing a pattern or texture within the circular form. This is a good example of how various materials and stencil techniques can be used in combination. Be sure to experiment with other objects and color combinations to create new and interesting effects.

1. **PAPER CLASPS** create an interesting contrast in focus. Where the clasps touch the painting surface, they produce a sharply-focused image. Where they are not touching, the image is soft and out of focus. The color was blended by first spraying YELLOW, concentrating it towards the center. RED and then BLUE are overlapped from both sides. Spray directly over the clasps.

2. **PUSH POINTS** are small metal shapes used for setting window glass, mirrors or for picture framing. They are commonly found in hardware stores. The colors are blended by first spraying RED around the outer perimeter of the circle. BLUE is then directed to the center. Conclude with just a bit of YELLOW added to the RED.

(Fig. 2)

(Fig. 3)

3. **THUMB TACKS** with convex heads permit the color to subtly drift under the tacks. This gives the small spheres a soft appearance. The color here is developed in steps by first spraying BLUE and RED from opposite sides. This same step is now repeated, allowing both colors to thoroughly overlap each other. Finally, a bit of YELLOW is added to the outer perimeter.

4. **PASTA** is available in many interesting shapes. The same sequence of colors used above also applies here.

5. **DOILIES** can be found which are made of lace, paper or plastic. Plastic doilies are most durable. BLUE and RED are sprayed from opposite sides of the circle, allowing them to overlap. Doilies, wire screen and cheesecloth are just a few of the materials which can be used to create patterns or textures.

6. **HOOK RUG SCREEN** or other similar materials are found in craft or hobby stores. The blending of color in this figure begins with a base-coat of YELLOW. BLUE and RED are then sprayed over the YELLOW, creating ORANGES and GREENS.

Note: Keeping a collection of special effects can develop into a useful reference file. As you experiment spraying different objects, begin grouping the results into categories. The categories may refer to the basic type of object or material used to create the effect. They may also be separated into effects suitable for abstract images and those more appropriate for naturalistic images, use your imagination. As was suggested for the color experiments on Page 38, make a notation next to each experimental pattern or texture. Indicate the material or object used to create the effect. Other noteworthy information such as color combination and whether the objects were placed in a flat or vertical position while spraying should be noted for future reference.

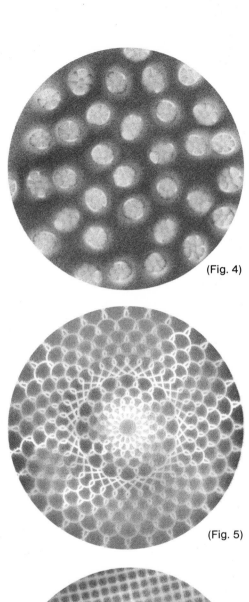

(Fig. 4)

(Fig. 5)

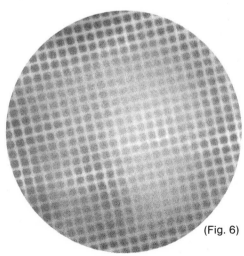

(Fig. 6)

HAND-HELD STENCILS

HAND-HELD STENCILS, also referred to as SHIELDS, are simply unattached stencils which are held in position while spraying. This type of stencil can be moved quickly, which permits you to take a spontaneous approach to airbrushing. Although the examples shown here are repetitive geometric patterns, free-form shapes can be easily produced by this method as well. Acetate makes a good reuseable material for hand-held stencils. You may wish to begin a collection of stencils which can be used repeatedly. Experiment with a variety of stencil shapes. Use the positive and negative portions of the stencil both singularly and in combination.

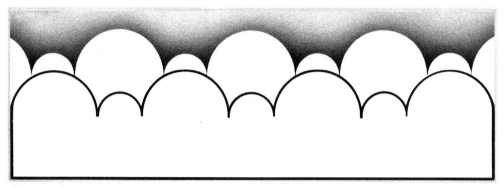

(Figure 1)

In *Figure 1*, only the positive part of the stencil is utilized. The stencil is shifted left and right as it is moved down the page. Align the large circular form with the smaller form as each row is airbrushed.

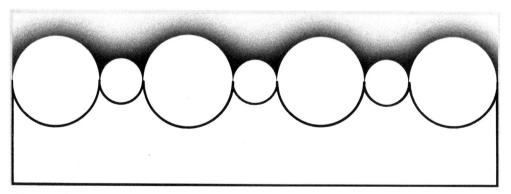

(Figure 2)

In this figure, both the positive and the negative parts of the stencil have been used. Begin by spraying over the positive portion of the stencil as in *Figure 1*. Next, switch to the negative stencil, aligning it in order to provide a full circle. Proceed by spraying along the stencil, creating a row of complete circular forms. When beginning the next row of circles you must again switch back to the positive portion of the stencil and repeat the procedure.

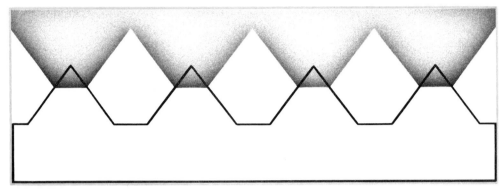

(Figure 3)

As in *Figure 1*, the stencil is shifted or off-set as each row is sprayed. Alternate moving the stencil right and left as you move down the page, again using only the positive portion of the stencil. Notice that the stencil is positioned so the top of each triangular shape overlaps into the row above.

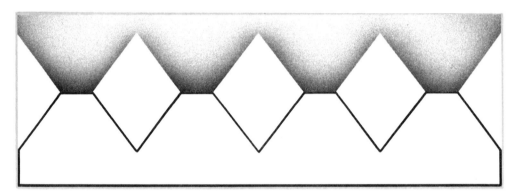

(Figure 4)

In *Figure 4*, both portions of the stencil are implemented. Once you have sprayed over the positive side, switch to its opposite half. Align the stencil in order to create a diamond shape. Spray over this half and again switch to the initially used positive stencil and repeat the process.

(Figure 5)

As described in common object stenciling, anything can be used as a stencil. The sphere featured here was produced by spraying over a common jar lid as it was held in place. Spraying over the lid creates a silhouette of the sphere; color is then airbrushed into the silhouette giving it volume and form. Any flat circular object can be used as a hand-held stencil to quickly produce a sphere.

COMBINING STENCIL TECHNIQUES

The images featured on this page were created with a combination of COMMON OBJECTS and COMMERCIAL PRE-CUT STENCILS. All of the stencils were hand-held during spraying. No adhesive materials were used for stenciling these designs. Holding and moving non-adhesive stencils by hand permits you to take a quick and spontaneous approach to airbrush painting.

AIRBRUSH RENDERING EXERCISES

PEPPER AND MUSHROOMS

This rendering requires the use of only one piece of frisket film during the stenciling sequence. As described on page 22, when a single frisket is used, the drawing is transferred onto the frisket film rather than the painting surface. We take exception to this approach for this composition because of the use of **LIQUID STENCILING SOLUTION.** The highlights on the pepper will be blocked out with liquid stenciling solution. A drawing of the highlights will be necessary to accurately apply the stenciling solution. Because of this, the drawing will be transferred onto the painting surface. Also, note some stencil parts will be replaced after spraying. KEEP ALL STENCIL PARTS after their removal by storing them on the frisket's protective backing.

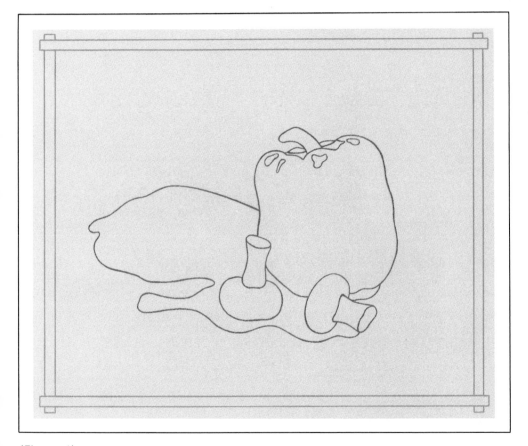

(Figure 1)

Tape off the borders of the page and transfer the drawing onto the painting surface after developing it on tracing paper. (See page 22, Developing Layouts And Transferring The Drawing.) Next, place the frisket film over the painting surface. Following the drawing carefully, cut the entire stencil EXCEPT for the highlights on the pepper. These areas will be blocked out with stenciling solution after the frisket is removed from the paper.

(Figure 2)

Begin this step by removing the frisket covering the pepper's stem and area surrounding its base. Using GREEN, airbrush this section by directing the spray towards its lower left side. Study the light source in this rendering. It comes from the upper right side of the composition, casting shadows to the left. Note: Remember to keep the stencil parts. They will be used for remasking later in the stenciling sequence. Next, remove the frisket which covers the main body of the paper. Once removed, use a paintbrush to apply liquid stenciling solution over the highlights. Note: The YELLOW color in the highlights indicates the application of STENCILING SOLUTION. Wait until the solution is thoroughly dry before airbrushing. The color of this pepper is developed by overlapping (green, blue and black). Starting with GREEN, begin building the denser areas of color first. Notice the slightly denser stripes of color moving vertically through the pepper. The values are developed in steps using several consistently airbrushed spray passes. Once the form of the pepper has been lightly but clearly established, change from green to BLUE. Simply continue to intensify and darken the values, trying not to overwork the lighter areas. Before you switch to black, which completes the pepper, REMOVE the dry liquid stenciling solution with a rubber cement eraser or a small strip of drafting tape. When all the dry solution is thoroughly removed and cleaned from the highlight, continue spraying with blue. Allow a minimal amount of blue to drift over the highlights. Now, change from blue to BLACK. Direct a few very light spray passes to the lower left portion of the form. Use the black sparingly; airbrush only a few diffused spray passes.

(Figure 3)

The stencil parts previously removed from the pepper are now carefully replaced. Replace the frisket covering the main body first. Should the smaller frisket parts of the stem begin to curl up, secure them to the surrounding frisket with drafting tape. You now REMOVE the frisket covering the mushroom tops and the flat bottom portion of their stems. Using SEPIA, airbrush a few light spray passes over these areas. Now, change from sepia to BLACK. Make a few light spray passes into the denser areas of color, lowering the values slightly. Next, remove the frisket covering the mushroom stems. The frisket has now been removed from all areas of both mushrooms. As illustrated in the second half of Figure 3, render the stems first with SEPIA and then with BLACK.

(Figure 4)

All frisket parts which cover each mushroom are now returned to the painting surface. The frisket which covers the shadow is next to be REMOVED. Do not overlook the small separate frisket part covering the shadow at the lower right side of the pepper. The sequence of colors used in rendering the shadow are BLUE, BLACK and a little RED. The shadow, like the other forms, is developed in steps, making several consistent spray passes with each color. Study the subtle changes in value in the finished shadow; do not overwork.

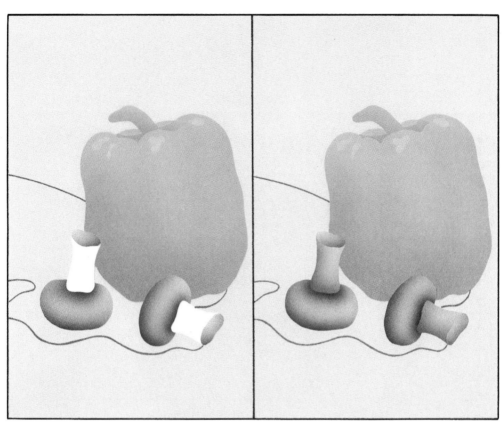

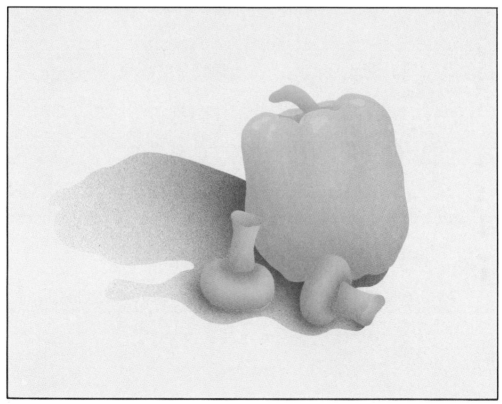

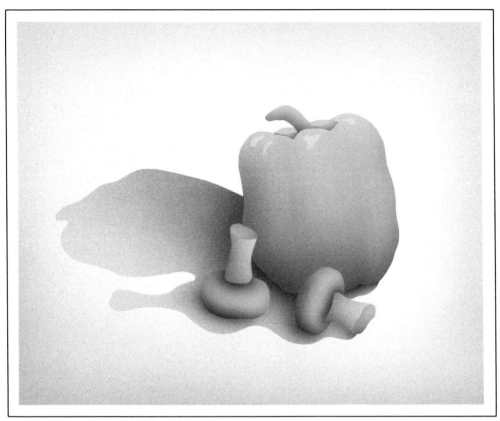

(Figure 5)

Upon completion of the shadow, REMOVE the frisket which covers the background area. Remove large pieces of frisket slowly to prevent damage to the painting surface. You are now ready to spray the final colors into the background. At this point in the stenciling sequence, the frisket has been removed from the background and also the shadow.

The frisket covering the completed pepper and mushrooms, however, should remain in place until the background has been rendered. To render the background, a series of blue, black and red spray passes is again airbrushed. The color is directed primarily to the edges of the composition, especially at the bottom. Allow a small percentage of this color to drift towards the center and into the shadow. When this final area is completed, remove remaining frisket covering the mushrooms and pepper as well as the taped borders.

Note: When your painting is completed study it carefully. Many times a bit of the white painting surface may appear along the contour of a stenciled form. When this occurs, a touch up with a fine sable paintbrush will eliminate the problem.

LILIES

REFER TO PAGE 22. When two separate sheets of frisket are used during the stenciling sequence as is the case for this exercise, the layout should be transferred to the painting surface. This avoids transferring the drawing twice for each piece of frisket film. Also note that the stencil parts will not be replaced after spraying. With a more complex composition such as this, the cutting of a second piece of frisket for blocking out finished areas is advised.

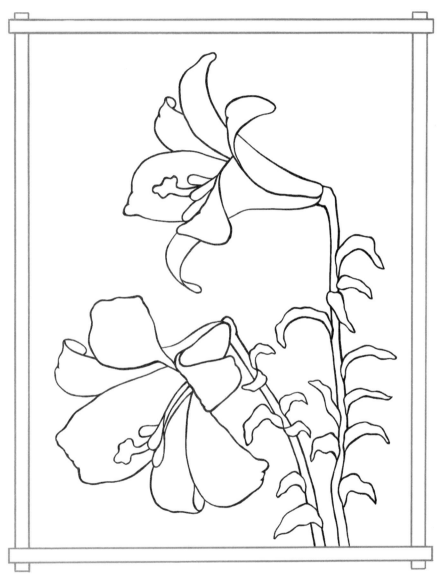

(Figure 1)

FRISKET ONE

Tape off the borders of the page. Spend adequate time studying the drawing and developing it on tracing paper. Once a clean, linear drawing has been completed, transfer it onto the painting surface. Check the transferred drawing for clarity of line and smudges. When the drawing is satisfactory place frisket film over the painting surface.

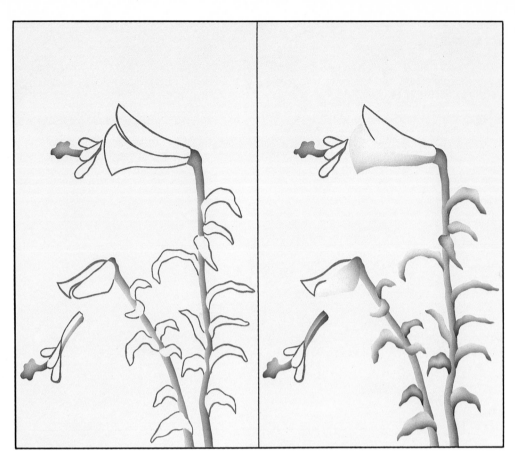

(Figure 2)

Notice that only a portion of the flowers will be painted while using the first sheet of frisket film. It is necessary to cut only those parts shown in *Figure 2* at this time. Be sure all sections intended for painting are cut before spraying begins. After cutting the stencil, remove the frisket from the main stem of both flowers. Also remove the two PISTILS which are the small green nibs protruding from the flower's center. In the lower flower only, two small green stems attached to the flower's STAMEN are viewed; remove the bottom stem. For reference, the stamens are the two groups of three red parts which also protrude from the center of each flower. Using GREEN, begin airbrushing the main stems first; then proceed to the smaller parts. As shown in the SECOND HALF of *Figure 2*, remove frisket and spray the remaining parts. When spraying the second small stamen stem, maintain a difference in the value of the color within each stem. The contrast helps to separate the two forms. The lower back portions of the flower PETALS are also sprayed green. Study the variations in the color's hue as it changes throughout the form. Do not overwork and destroy the light areas within the shape.

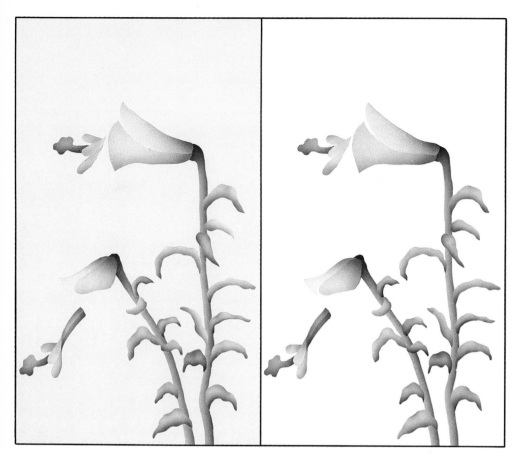

(Figure 3)

Change from green to RED. Remove the frisket and spray the outer stamen of each flower, while leaving the frisket in place on the inside stamen. Next, remove and lightly spray over the two remaining inside stamens. Notice the lighter value of the center form creates contrast which again helps to separate the shapes. Try to contain the spray to only the designated areas when using the red. Inherently, there will be some overlapping into the green. A controlled, minimal overlap, however, will soften edges and help the forms flow from one to another with a more naturalistic appearance. The upper back portions of the flower petals are the final sections to be sprayed while using this piece of frisket film. Remove the frisket and spray the top section, letting the red drift down into the lower area of the petals as well. To conclude this step, change back to green and simply re-spray the top petal, overlapping green into red. You may again allow the color to drift down into the lower petals by adding additional green. This will lower the value of the colors. As illustrated in the second half of *Figure 3*, remove the entire frisket from the painting surface.

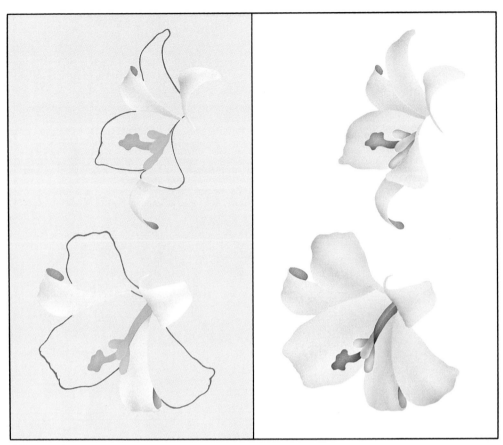

(Figure 4)

FRISKET TWO

A second sheet of frisket film is now placed over the painting surface. Begin cutting around the pistil and stamens which you have already completed. The frisket will pro- tect these parts as the flower petals are airbrushed. Proceed by cutting all the individual petals. A small area of the back side of two petals curls back and under. Remove these four small sections of frisket and spray a few light passes with RED. You must now change from red to BLUE. Remove the frisket from every other petal and render with blue. Allow the blue to overlap the small red areas just sprayed. As indicated in the second half of *Figure 4*, remove and render the remaining petals, again using blue.

Changing from the blue to RED, lightly and carefully spray into the predominantly blue petals, defining their form and giving them volume. To conclude this painting switch from red to YELLOW. Spray just a hint of the yellow into the center of each group of petals. The yellow is added using a diffused, broad spray. This means the airbrush will not be positioned close to the painting surface. The yellow is added merely to warm up the colors toward the center of the petals; it is barely recognizable.

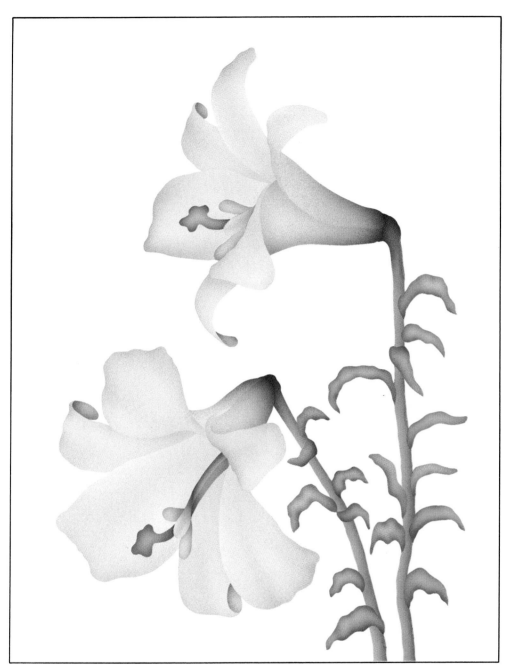

(Figure 5)

You may now carefully remove all the frisket film and tape from the finished airbrush rendering.

FLAMINGOES

The following composition is an excellent example of the necessity of using more than one sheet of frisket film. As described on page 22, accurate replacement of intricate stencils can be most difficult. Compositions such as this often require applying and cutting several sheets of frisket film. Another facet of this rendering worth noting is the stylized approach it takes. Where renderings such as the *"Pepper and Mushrooms"* or *"Lilies"* take a more naturalistic approach, this is quite stylized in comparison.

The use of outlining in the forms is a characteristic unique to the stylized look. Outlining a shape clarifies and intensifies the contour of the form. It also tends to visually flatten the shape, giving it a graphic or stylized orientation.

(Figure 1)

FRISKET ONE

This rendering will utilize a total of three separate pieces of frisket film. Considering this, the drawing must be transferred directly onto the painting surface. The circles should be centered within the page and applied with the aid of a compass. When the drawing is complete, apply the frisket film.

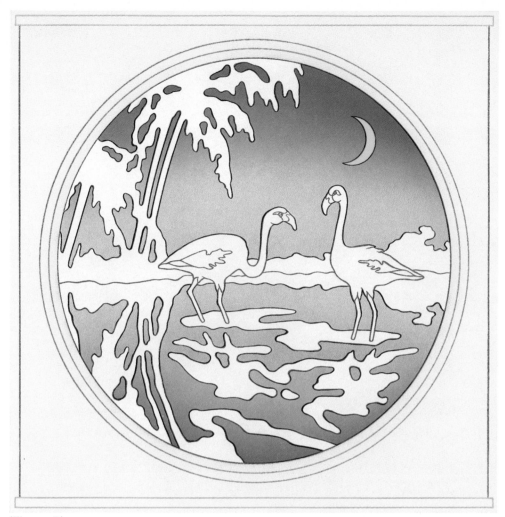

(Figure 2)

Begin the stencil by cutting and smallest INSIDE CIRCLE. Proceed to cut around the MOON and TREES. The negative space within the contour of the trees is also cut. Next, the reflections of the trees and flamingoes in the water are cut. Again, the negative spaces within these areas are cut out. The final shapes to be cut are the flamingoes. Notice that it is not necessary to cut the entire form. Only the portions of the birds that overlap into the sky and water are required. Do not cut any of the internal sections of the flamingoes. When all the cutting is completed, remove the frisket which covers the MOON. NOTE: This is the only stencil part that will be replaced. Be sure it is kept for reuse by storing it on the frisket's removable backing. Proceed to airbrush the moon with several fine coats of YELLOW. When the yellow is sufficiently dry, replace the stencil part which covers the moon. Next, remove the frisket covering the sky and water. This must be done carefully so the remaining frisket is not pulled up as well. Before spraying the sky and water be sure the remaining frisket is securely in place. You are now ready to airbrush the sky and water. Begin spraying RED onto the frisket covering the horizon line, working it above and below the horizon.

Use a series of horizontal spray passes to apply the color. Changing from red to BLUE, spray the color from the top and bottom, working it slowly toward the center. The blue is subtly overlapped into the red; however, it's much denser at the top and bottom. Care must be taken not to overwork the mid-section of composition. When both colors have been established, remove the stencil and replace it with an entirely new sheet of frisket film.

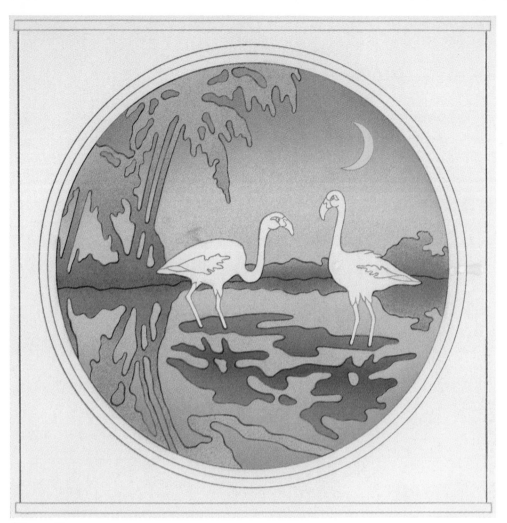

(Figure 3)

FRISKET TWO

You must now cut your stencil from the second sheet of frisket film. Begin by cutting around the inside circle. Proceed with the trees, flamingoes and reflections. Next, remove the frisket covering the reflections of the flamingoes. Proceed to airbrush the reflections with RED. SEPIA should then be overlapped into the mid-section of the reflections. You are now ready to render the trees and their reflections. Before proceeding with this, however, tape down a piece of paper which covers the flamingoes' reflections, making sure they are completely covered. You do not want your next color, which is green, to seep under the paper and into the red.

The frisket which covers the trees and their reflections can now be removed. Sepia is then sprayed into the horizon, working the color up and down the page. The color is fairly dense at center but is quickly faded out as it moves up and down. Note: Sepia will be sprayed over this same area after green has been added. The color's dark value in this area is developed by layering sepia, green and again sepia. (Layering color in this manner is useful when darker values are desired.) Proceed to airbrush the GREEN just as the sepia was applied. Start your spray passes at the horizon and systematically move up and down the forms. When the green has been well-established, remove the entire stencil and replace it with the THIRD and final sheet of frisket film.

FRISKET THREE

A. The remaining elements in this composition yet to be rendered are the circular border of color and flamingoes. Begin by carefully cutting along both sides of the circular border.

B. Next, cut out the entire contour of the flamingoes and all lines within the contour. Remove the frisket covering the flamingoes' legs, wing tips and ends of beaks. Spray the legs with a few light passes of BLACK. The legs are slightly darker where

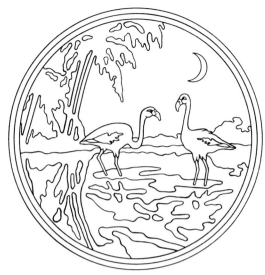

(Figure 4)

they meet the body. The beaks and wing tips are also rendered with black, although much darker.

C. Continue by removing the frisket covering the upper portion of the wings. Remember the stencil parts are not replaced as you proceed. Using RED, spray the wings with a dense layer of color.

D. The frisket covering the bodies is now removed and lightly rendered with red. Just before the bodies have been completed, remove the frisket which covers the eyes and back section of the beaks. As the bodies are completed, allow a little red to drift into these areas.

Once the flamingoes have been completed, the circular border is the last element to be airbrushed. Before this is accomplished, the flamingoes must be completely covered to protect them as the border is sprayed. Do not try to replace the small parts which originally covered the flamingoes. Cover them with a piece of scrap paper or acetate. Tape the edges of the paper to the surrounding frisket which covers the rendering.

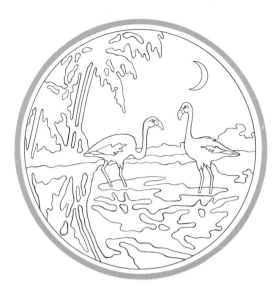

(Figure 5)

A. Remove the circular border and airbrush with RED. When this is accomplished remove the entire stencil.

B. To complete this rendering, the features of the flamingoes are now clarified by outlining with a fine sable brush. SEPIA or BLACK may be used. You may wish to outline other areas throughout the composition as well.

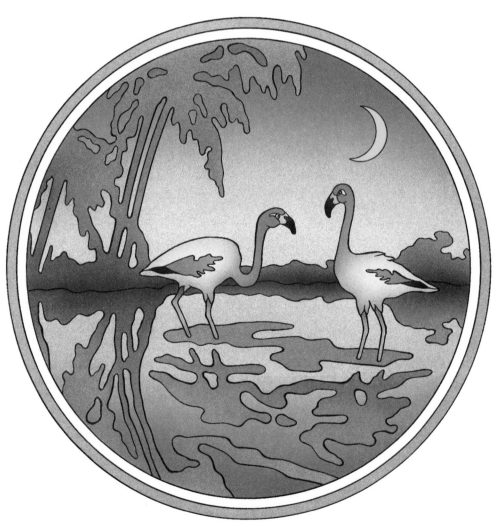

PHOTO RETOUCHING

The following information is an introduction to photo retouching. This will provide a few basic guidelines for the materials and approaches used in this technique.

The technique known as photo retouching basically involves ADDING to, SUBTRACTING from, or ENHANCING a photographic image. The majority of photographs used in major advertising promotions (fashion, product and technical) have been altered or enhanced through photo retouching techniques. These same techniques may also be used in a fine arts context to transform the photographic image to meet the artist's vision. Considering the grain and smooth surface of a typical photograph, the internal-mix airbrush is recommended for spraying on photographic surfaces.

Photographs should always be cleaned before work begins. A tissue and rubber cement thinner will remove fingerprints or any photographic chemical residue on the PRINT. Use care in handling the photograph, avoid touching its surface.

An additional copy of the print is recommended to be used as reference when retouching the original. The copy can also serve as a back up should an irreversible mistake occur.

When the retouched print is intended for reproduction, the original photograph should be one and one half to two times larger than the reproduction SIZE. This assures a tight, clean FINAL image.

Opaque gouache, ink and dye are the traditional medias of retouching. Acrylics and pre-reduced airbrush pigments are also commonly used. Both resin-coated and fiber-base stock can be used in photo retouching.

Mounting your photograph on single ply, acid-free board is recommended. Rubber cement, spray mount or pressure adhesives can be used for mounting. Should you not wish to mount the photo, simply tape your corners to a stiff board while working.

Inks and dyes are primarily used for tinting or coloring. Gouache and dye are water-soluble when dry, this permits them to be removed from the photo with water without damaging the emulsion.

Clear lacquer aerosol sprays designed specifically for use on photographs are available through suppliers of photographic materials. Most clear lacquer sprays that are suitable for standard art work can also be used on photographs. The clear lacquer is used to fix the various medias and to protect the photo. It also gives the surface a tooth which increases adhesion of the media. This can be especially important when colored pencils are used in conjunction with the airbrushed media. Colored pencil which is helpful for detailing and highlighting, needs a layer of lacquer in order for it to adhere to the surface. Before using the colored pencils be sure the spray lacquer is thoroughly dry (a hand-held hair dryer can speed up the process). For best results apply the pencil using a light touch. Excessive pressure will break down the tooth of the lacquer coating and the colored pencil will not adhere. Also note, when dense, opaque tones are desired additional layers of spray lacquer may be necessary.

When retouching a photograph by airbrushing, penciling or a combination of both, noticeable inconsistencies in surface texture and sheen will occur. A final coat or two of the clear spray lacquer will eliminate these inconsistencies and give the print an even finish.

The surface of a photographic print tends to be quite delicate. For this reason the acetate stenciling technique which avoids cutting into the surface (see page 32) is most appropriate for stenciling photographs.

Also note, when it is intended for the retouched image to be rephotographed for purposes of reproduction, the actual retouching may be done on a wet-media acetate overlay. Refer to information on acetate (page 17).

WHITE GRAY #1 GRAY #2 BLACK

The acetate stenciling technique described on page 32 is utilized here, remember to score the acetate, do not cut completely through to the surface.

Airbrushing begins with WHITE and LIGHT GRAY and continues with the DARKER GRAY and BLACK.

Develop the color slowly, layering the medium with a series of spray passes.

A few coats of clear lacquer is applied after airbrushing the background.

Colored pencils are then used to soften the contour of the hair.

The pencil also intensifies highlights and clarifys the features.

When all of the retouching is completed, a final coat of clear lacquer is applied.

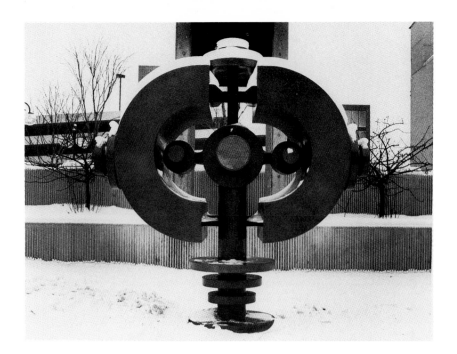

CRYSTAL VISION - Stainless Steel Sculpture By Peter West

The snow has been removed from the sculpture. All parts of the sculpture which were previously covered with snow are then reconstructed with the airbrush and colored pencil. The area surrounding the sculpture is diminished by airbrushing a uniform layer of color over the background. This clarifys and isolates the object of interest in the photo.

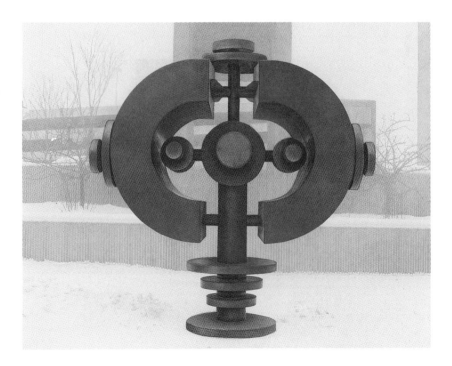

SINGLE COLOR PHOTO SILK-SCREEN PRINT

The moon, sky and color in the water were all added with the airbrush, some brush work was also added. This example shows the use of photo retouching techniques being used to create a fine art print.

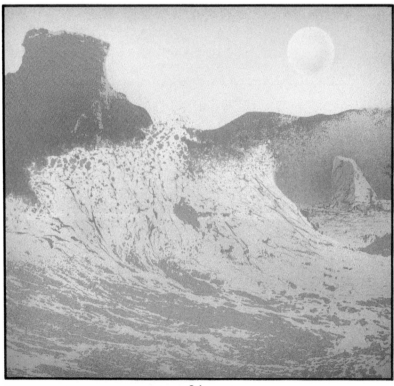